BARREN ISLAND
BATH BEACH
BAY RIDGE
BEDFORD-STUYVESANT
BENSONHURST
BERGEN BEACH
BOERUM HILL
BOROUGH PARK
BRIGHTON BEACH
BROOKLYN HEIGHTS
BROWNSVILLE
BUSHWICK
CANARSIE
CARROLL GARDENS
CLINTON HILL
COBBLE HILL
CONEY ISLAND
CROWN HEIGHTS
CYPRESS HILLS
DOWNTOWN BROOKLYN
DUMBO
DYKER HEIGHTS
EAST FLATBUSH
EAST NEW YORK
EAST WILLIAMSBURG
FLATBUSH

FLATLANDS
FORT GREENE
GERRITSEN BEACH
GOWANUS
GRAVESEND
GREENPOINT
GREENWOOD HEIGHTS
KENSINGTON
MANHATTAN BEACH
MARINE PARK
MIDWOOD
MILL BASIN
NAVY YARD
PARK SLOPE
PLUMB BEACH
PROSPECT HEIGHTS
PROSPECT LEFFERTS GARDENS
REDHOOK
SEA GATE
SHEEPSHEAD BAY
SUNSET PARK
VINEGAR HILL
WILLIAMSBURG
WINDSOR TERRACE

ON THE ROOF

New York
IN
Quarantine

JOSH KATZ

FOREWORD BY RUMAAN ALAM

Table of Contents

Foreword

A city is a group effort. It's a collaboration. It's a party to which all are invited, a place to which all can lay claim. It's immaterial whether you've lived all your days in some family homestead or are a tourist spreading a blanket in the park; you're here. Taking up space means taking part in the experiment that is a city.

How I love the ingenuity of city dwellers—I'm talking about my neighbors in New York, but this is a quality you find the world over. When space is at a premium, you need to get creative, like the kids who turn the F Train into a store selling candy at a 200% markup or the determined souls who transform their block's tree pits into their own personal Versailles. Where life is expensive, you find treasure in your fellow man's trash, like the gardener who tends her crops with runoff from the neighbor's air conditioner, the apartment dweller who claims the stoop as her sitting room.

Josh Katz's photographs of New York in 2020 are a document of a significant era—what quarantine and social distance looked like in one of the world's great cities. This makes them important.

But what I love about these pictures is something else altogether. It's how they capture the essential quality of urban life, adapted for the conditions of reality during the COVID-19 pandemic. New Yorkers claiming space, finding joy, insisting that things will go on. A woman lies on her belly, feet kicked up behind her, scribbling in her notebook, her graffiti-covered patch of the city as sacred as any artist's garret. A couple enjoys oysters and wine, their rooftop as romantic as any bistro you could name.

Josh's pictures also offer us, vicariously, one of the greatest thrills of life in the city, the frisson of voyeurism. His camera's not intrusive, not really; we all know that urban life offers not privacy but anonymity. We move through our days at peace with the knowledge that we might be seen. I once watched a young man in the apartment behind me, completely nude, smoking what I can only assume was a post-coital cigarette on his fire escape. We made eye contact across the hundred yards separating us, then went about our business. We've all seen something more outré than we've dared do ourselves, but we all know we, too, might do as the spirit moves us. It's our city, after all.

*

When COVID-19 closed schools and workplaces, some New Yorkers lit out for beach houses or the parental spread in the suburbs. I don't blame them. Life here can be challenging at the best of times. I think they know they missed out on something. They gave up the opportunity to bear witness to tremendous loss (of livelihood, of life itself). This responsibility is an essential part of the bargain of city life: you have to care about the other people who are all around you. Those who remained banged on pots at an appointed hour and waved to faces familiar enough that you could recognize them even beneath a mask from across the street: the lady you always see moving her car, the guy from the bodega whose name you've never known. In Josh Katz's photos of strangers, I recognize people I sort of know, and I recognize myself.

If the worst thing that happened to you over the months of quarantine was that you missed other people, you're lucky, and you know it. Human company is a joy, a necessity, but these were temporary circumstances, mercifully. It was no fun, but what could we do besides attempt to make it fun?

I don't have access to a roof of my own, but those early spring days, I took my sons and their bikes to the small parking lot of a nearly finished but then-uninhabited apartment building in our neighborhood, Crown Heights. We claimed this space for ourselves and the handful of passersby gave us a wide berth, the sacred bond of social distance. The boys raced around in circles (it's a tiny lot, the size of most exurban driveways), screaming mightily through their masks. The guys finishing construction inside peeked out at us, understood immediately, and went back to their work.

We trudged to this lot in rain or sun, cold or less-cold. One magical day, we found a dollar bill lying on the sidewalk. A block away, we found another. Then, and I know this beggars belief, still another. Inexplicable good fortune; we bought a bag of Doritos with the bounty.

My kids learned something, that miraculous day we found three dollars, and it's akin to what I learn anew when I look at Josh's photographs. The city that you think you know, the place my kids have dwelt since birth, can always surprise you. It has endless frontiers, whether parking lot or roof, where a private moment of joy might await you. Look up. Look down. Look all around. This city is yours. This city is ours.

RUMAAN ALAM

Introduction

When **New York City** emerged as a pandemic hotbed, rooftops became a respite from cramped apartments; often our only escape.

When my roommate Carly got sick, I submitted to eight days of isolation in our apartment in Bushwick, Brooklyn. Finally, as the city was retreating into quarantine around me, I climbed my building's ladder, jimmied off the hatch locks, and emerged onto the roof. My block's interconnected rooftop spans 17 apartment buildings—nearly two football fields—providing sweeping views of hundreds of surrounding rooftops, perfect for surveying the roof culture that emerged over the coming months.

Throughout the spring and summer of 2020, I spent hundreds of hours photographing life unfolding on these rooftops. I also chronicled daily observations in my journal, speculating on my neighbors' adaptation to the intensive quarantine. This body of work is the result.

As quarantine pushed the city into isolated desperation, the roof came to feel like a socially distanced block party every night. This project became the excuse I've always wanted to meet my neighbors.

From tabletop frolicking to Sinatra's "New York, New York" to head-spinning b-boys and choreographed waltzing, I watched my neighborhood dance. I followed cross-rooftop relationships developing between children, lovers, and cats. I endured the cacophony of a building's musicians uniting to perform rooftop concerts. I befriended the pigeon fanciers who fly their 1,000 birds every day, rain or shine, including Gil, who claims to love them more than his wife.

I admired balconies converted into drag show runways and fire escapes converted into art studios, reading nooks, and dining rooms. I witnessed a man ask a woman out using a drone. I saw inflatable pools, protests, and the exchange of flirtatious messages across rooftops via poster board. I feared for the life of a man casually strolling along the edge of his roof's parapet, one misstep away from death (but he does burlesque, so it's second nature for him). I was flashed twice. I won't miss screaming across two rooftops over blaring sirens and wind to communicate with my subjects, but I'm thankful for the new community that opened up to me during these long months.

Though this project celebrates hope and the whimsical side of quarantine life, I don't mean to neglect the pandemic's unfathomable toll. 100% of my profits from this book will go to Doctors Without Borders, a nonprofit providing humanitarian medical care, medical training, and emergency response services in destabilized regions around the world. Their work includes, but isn't limited to, fighting COVID-19.

JOSH KATZ

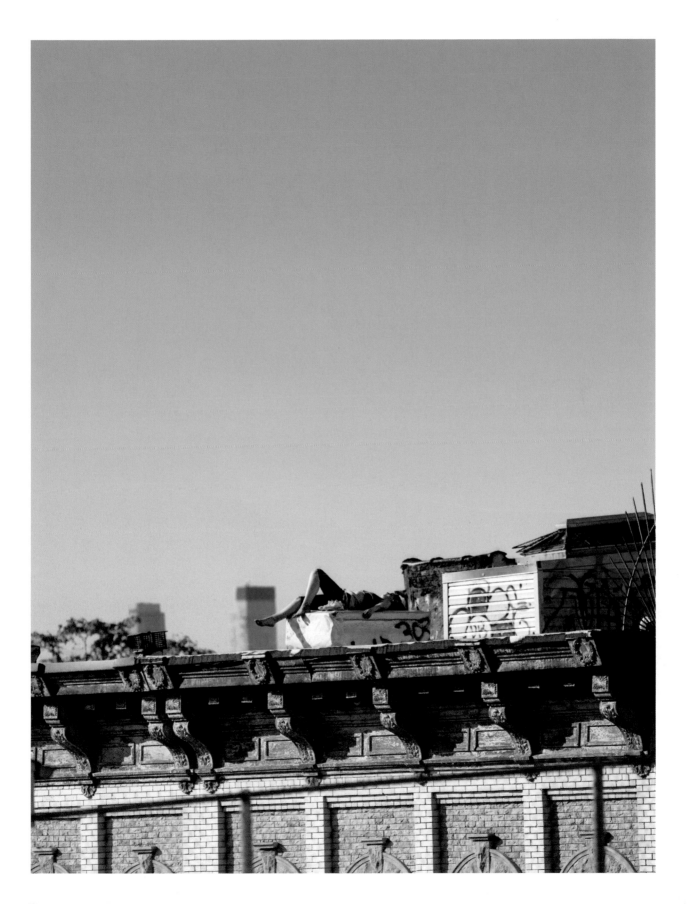

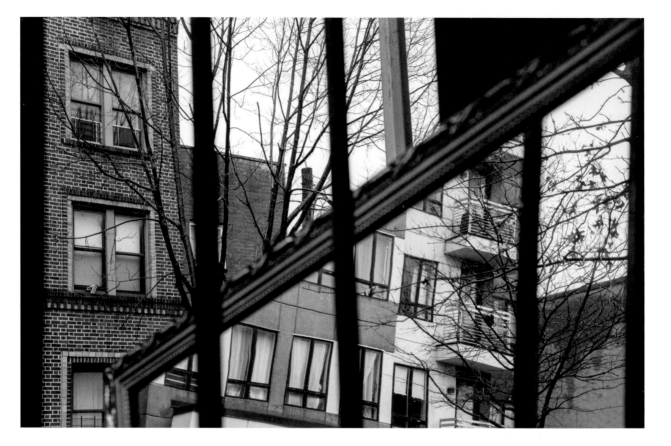

FALSE START (MARCH 13)

COVID-19 came to New York in fearful whispers and coughs on the subway before the tidal wave became fully apparent. March was a unique month with a mix of uncontained fear and blissful ignorance, as some were Lysol spraying their shoes upon entering their homes while others were still going clubbing.

It was at this point when my roommate Carly came down with a high fever and started having difficulty breathing. While we suspected it was COVID-19, CDC guidelines were vague and it was impossible for her to get tested, so we crossed our fingers and began to quarantine.

To be honest, I was terrified to stay in the same space as my sick roommate, but there was no alternative that wouldn't put others at risk. It was bizarre being quarantined but healthy. As a work-obsessed freelancer, I can easily spend days without leaving my house. In some ways, I've been quarantining for years and the events of 2020 only formalized it. But when the freedom to leave is removed, one day of quarantine feels infinitely longer than a week spent lost to the world, focused on my creative work.

My feelings of isolation were exacerbated by looking out my window to see people going about their normal lives. Choosing to embrace this discomfort through creativity, I set out to satisfy my yearning to interact with the outside world with a photo project. I dangled a gold-painted plastic mirror out the window to photograph reflections of passersby on the sidewalk (which, coincidentally, is where I found it). After 30 uneventful minutes, my photos were lackluster and the interactions were fleeting. This fragmented connection to the outside world wasn't going to cut it.

While I'm not remotely proud of this image, it represents something important—the beginning of my documentation of community in quarantine. As an artist, I've always enjoyed embracing limitations, finding that unexpected situations, and those that others overlook, prompt me to be creative in ways I never imagined. When my sequester was complete, much of the city had trickled into their own quarantine. As the world rapidly reinvented itself, I saw the rooftop perimeter as my new limitation and this story began to unfold.

INSPIRATION (MARCH 20)

I managed to jimmy the locks off my rooftop hatch. After eight days of total isolation, my roommate and I climbed up to the roof to eat cake.

On the way, I knocked on the doors of two apartments in my building, inviting the neighbors to join. We sat in a socially distant circle, feeling liberated after leaving our apartments for the first time in a while.

This taste of freedom inspired a photo series idea: document the changing community and culture of the rooftop during the pandemic.

GROUND RULES

1. Go up to the roof every day and stay up there. Read, photograph, write, draw, listen to music, etc. Always have a camera on me.

2. Interview people who climb up and take photos of whatever they're doing.

3. Find Gil, the local pigeon fancier, and learn the story of the neighborhood.

4. Decide how much impact I want to have on the developing roof culture. I could encourage my neighbors to join or let everything play out naturally.

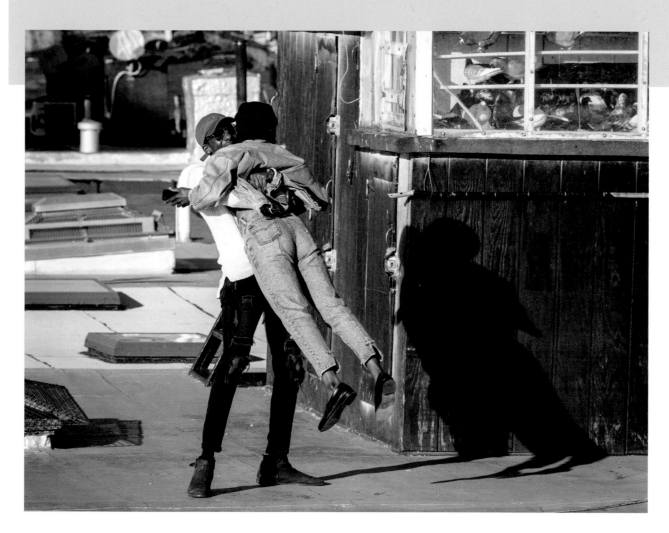

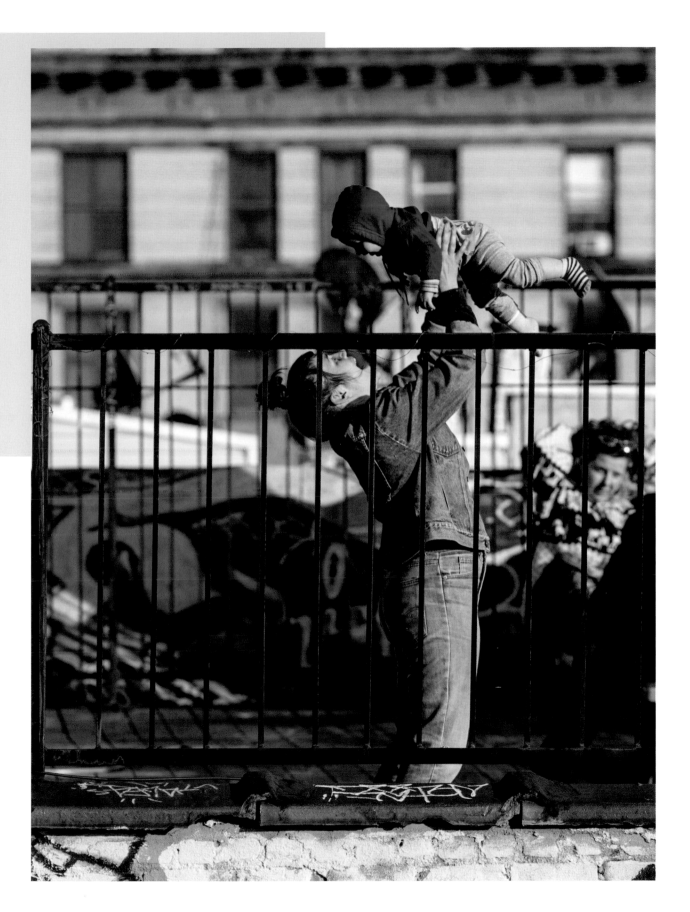

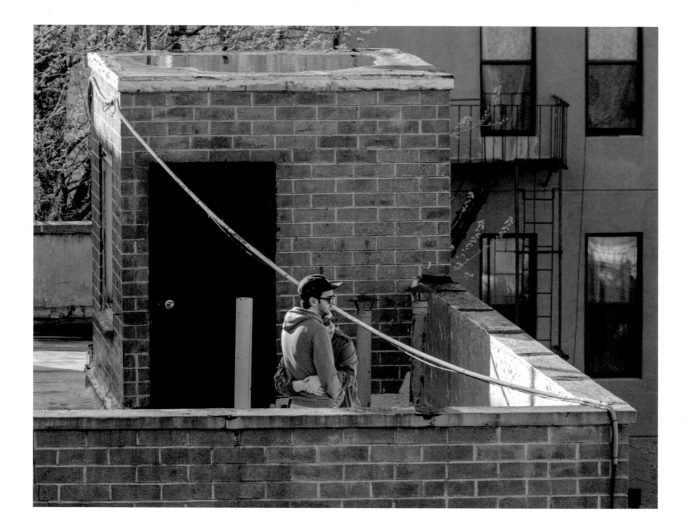

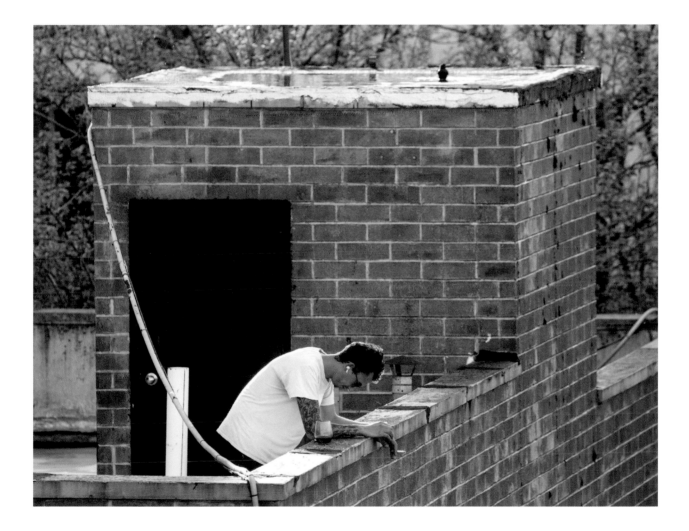

EMERGENCE (MARCH 22)

Watching people emerge onto the roof from their fire escapes and hatches, climbing out into the sun for the first time in days, reminds me of a submarine and its crew resurfacing after a long stint under-water. Relief, relaxation, and celebration are in the air.

Balls, scooters, and hula hoops are being rummaged from closets, neighbors are finally getting to know each other, drinks and dancing are plentiful, the Pigeon Kings are letting their birds fly, and fireworks* are going off after sunset.

The pigeon fanciers, who keep 1,000 pigeons on my roof, are elated by all the action. The roof is their territory—they've been coming here every day for years—but they welcome any company. Gil keeps binoculars handy at all times, allegedly to watch for hawks, but mostly uses them to keep an eye on the new roof dwellers.

It almost feels like an ordinary Saturday afternoon until something mundane—like offering someone another beer—reminds you that social distancing is at play. Roommates are all clustered together since cramped New York City apartments don't afford the luxury of social distancing from one an-other, anyway. However, people are excited to talk to anyone except their roommates, so there's a funny cross-pollination of half-shouted conversations at all times.

Seeing new people for the first time in a week is enlivening. No one knows how long this will last. I'm convinced we could be in it for the long haul, so I'm making an effort to say hello to everyone. I've befriended neighbors whom I've somehow never seen before.

*Anyone who quarantined in New York City is well aware of the diminishing returns of mysterious nightly fireworks after hearing them going off until 4 a.m. for months straight. But at this moment, the city still had a healthy appreciation for fireworks!

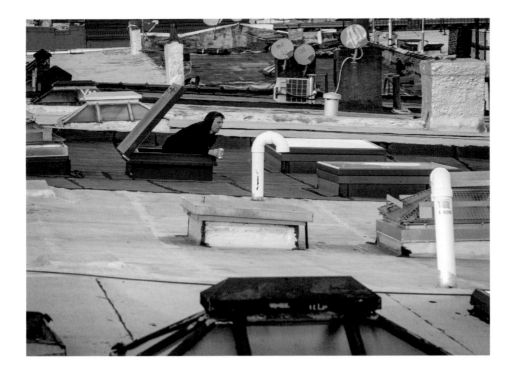

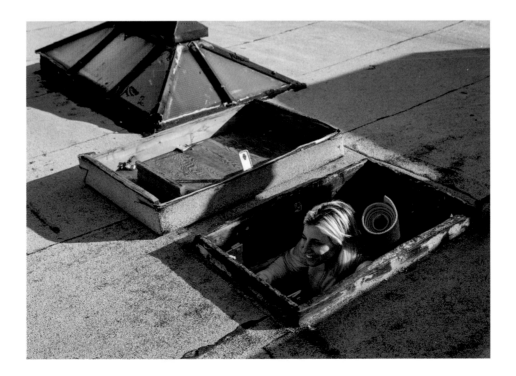

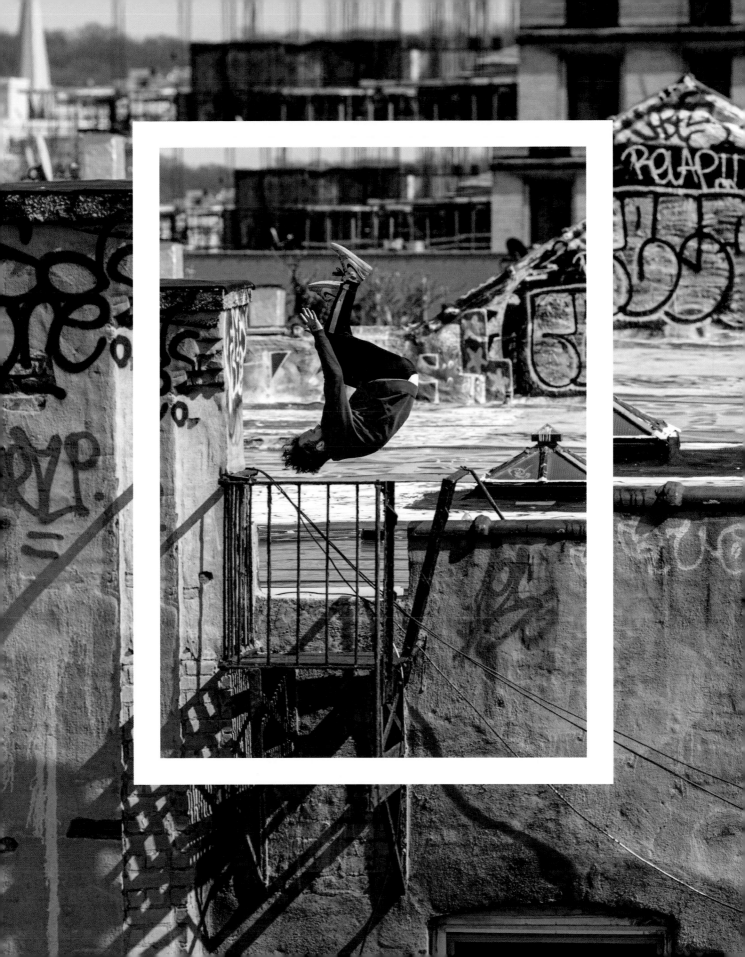

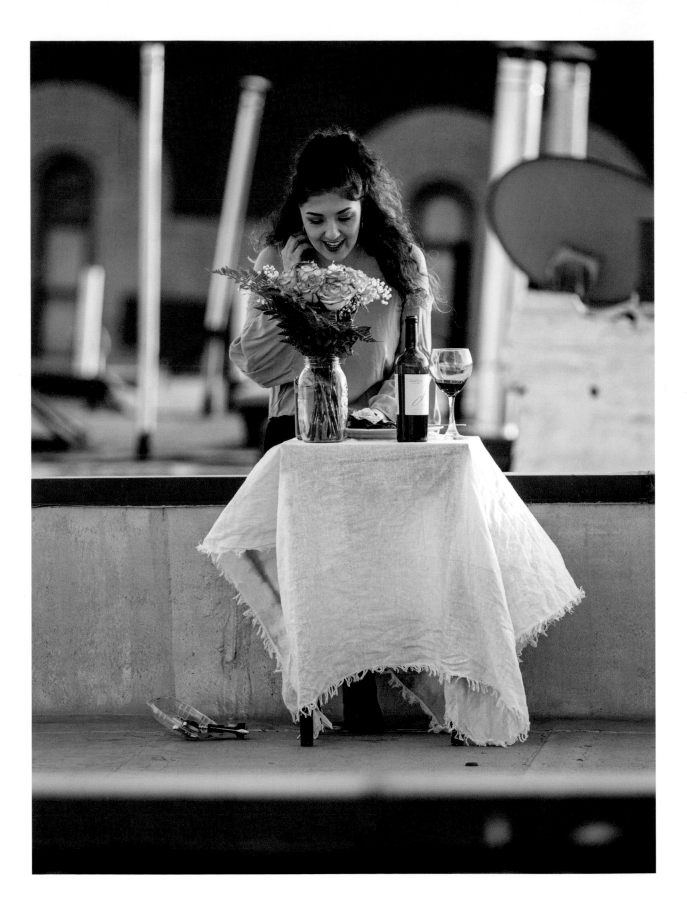

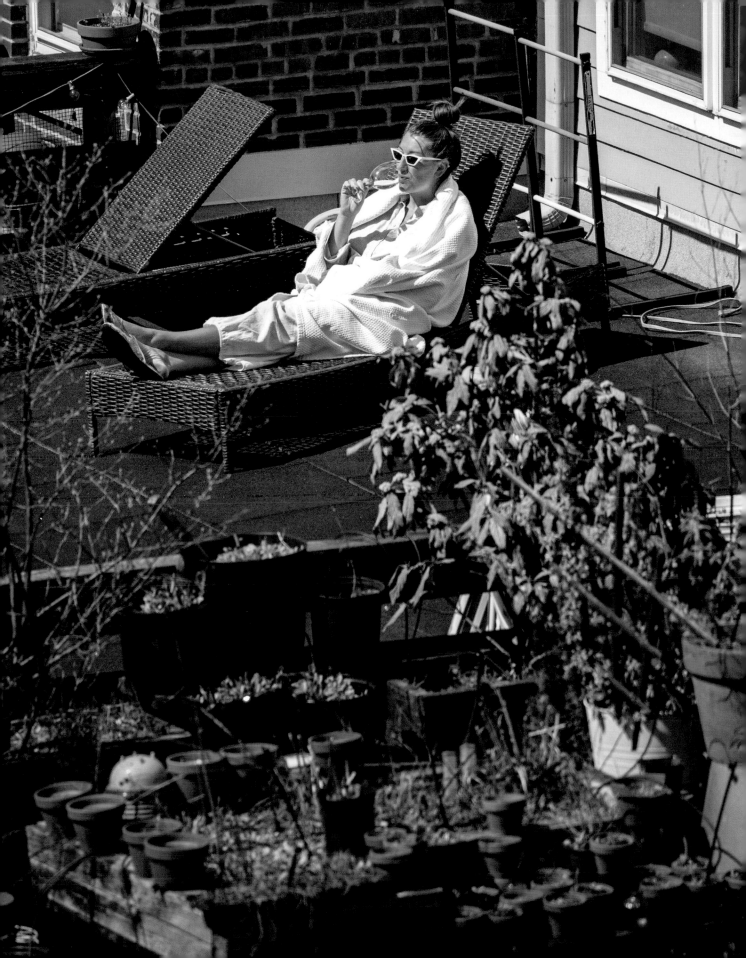

MEETING THE NEIGHBORS (MARCH 25)

My roommate skipped town today, packing up all of her belongings because she's uncertain when she'll return—maybe in a few weeks, maybe in a few months. Her parents, paranoid as ever, Lysol-sprayed everything she owns, including her body. I am now entirely isolated, but the roof gives me hope.

For the first time in ages, New Yorkers are getting to know their neighbors. I've seen so many introductions these last few days, often between residents from the same building. This is the strongest sense of community I've ever seen in my neighborhood.

People are getting comfortable on their roofs, living more of their lives up there. I watched a baby learning to crawl, a dog being walked, people doing yoga and dancing, and a man who's gotten terrifyingly confident strolling along the parapet. I also just learned that low protective walls along a roof are called parapets.

Since all the surrounding rooftops are close enough for conversation, I've been more than just a passive observer. I chatted with a veteran police officer who saunters around his station's rooftop in solitude, smoking cigars and observing the neighborhood like a king trapped in his castle. I philosophized for hours with a Hungarian fashion designer about sexuality and COVID-sanctioned abstinence. More than anything else, I bantered with the ever-present pigeon fanciers, learning about Bushwick's history, the art of flying pigeons, and quite a few dirty jokes.

Since everyone is working and socializing through video chat, there's speculation that the post-pandemic world will be more virtual than ever. Yet the connections I'm seeing on the roof give me hope for a shift in the opposite direction—a newfound appreciation for the people around you, a revitalization of local communities.

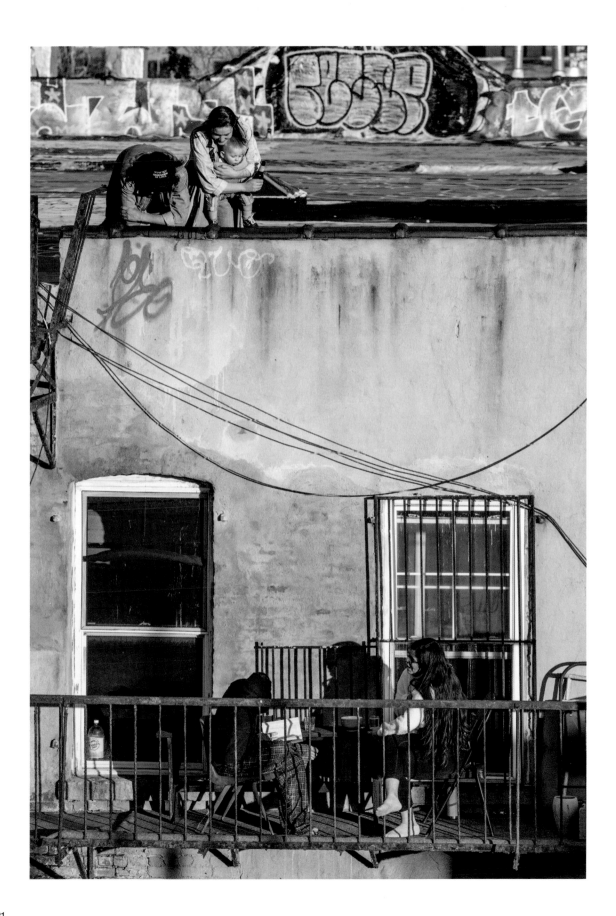

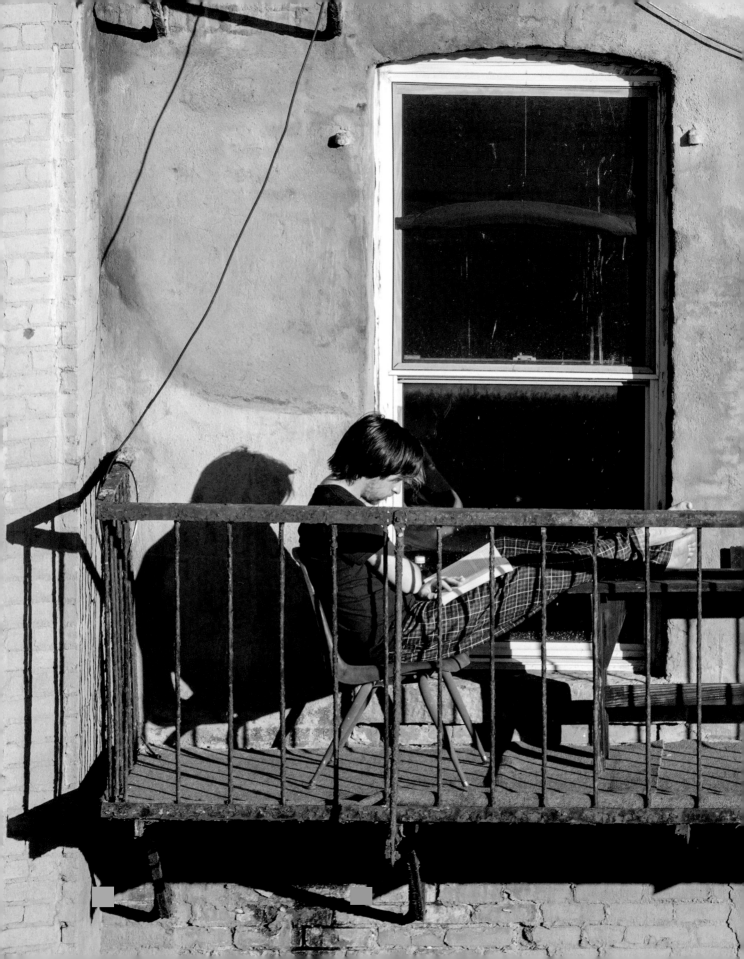

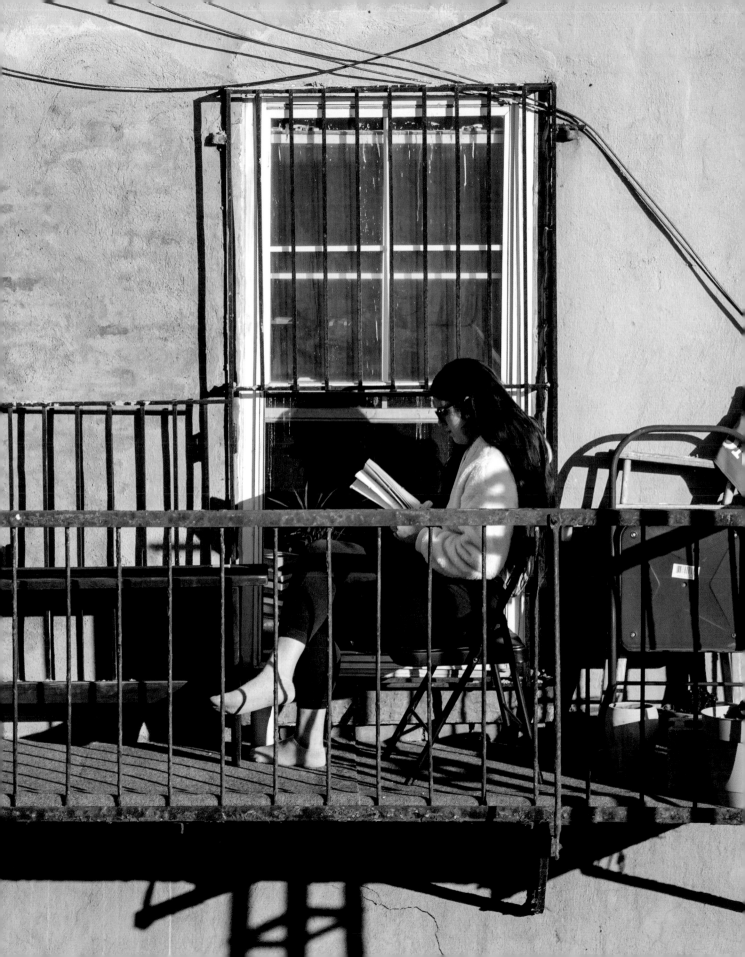

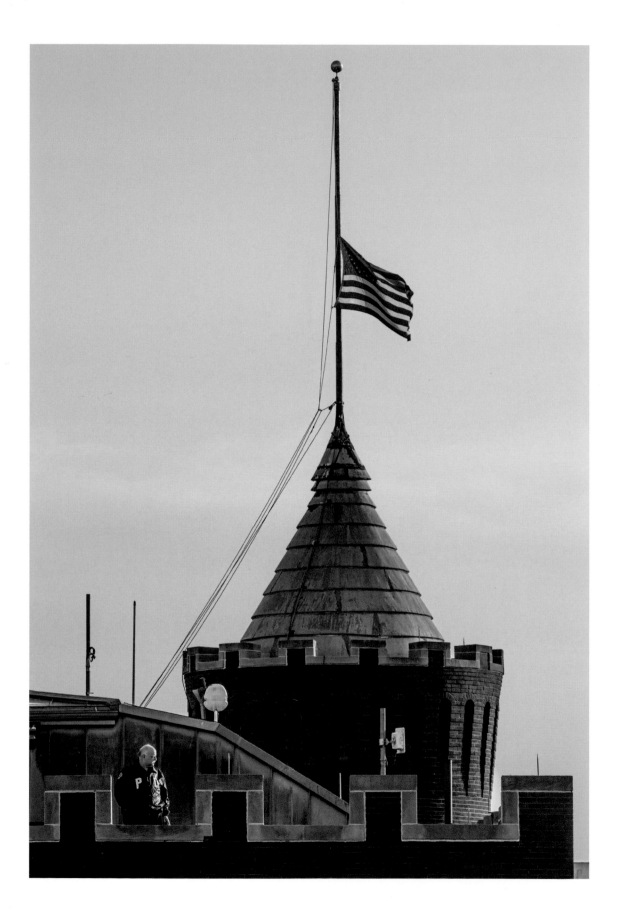

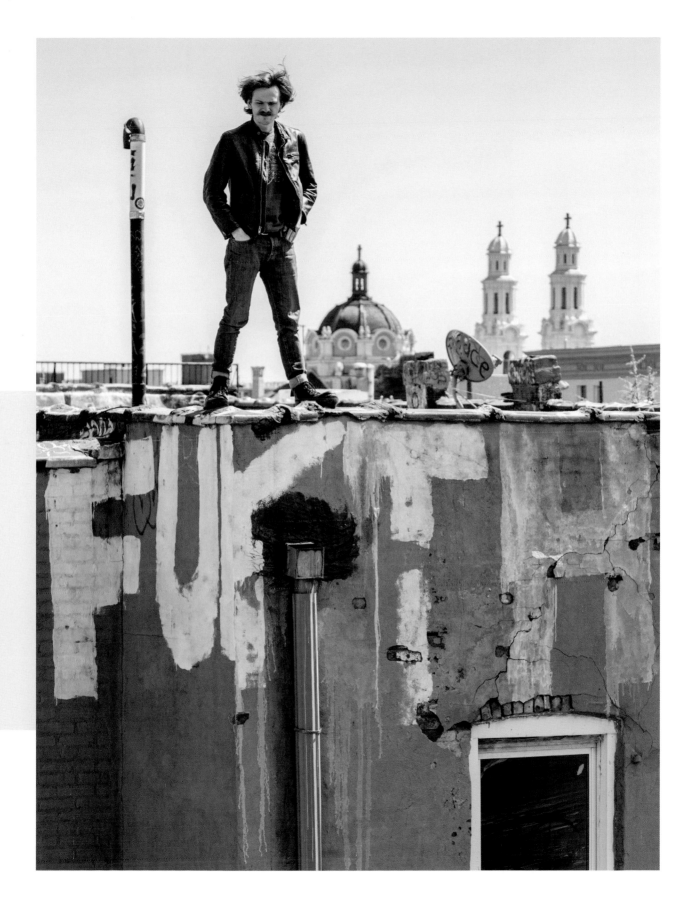

PLAYDATE DREAMS (MARCH 27)

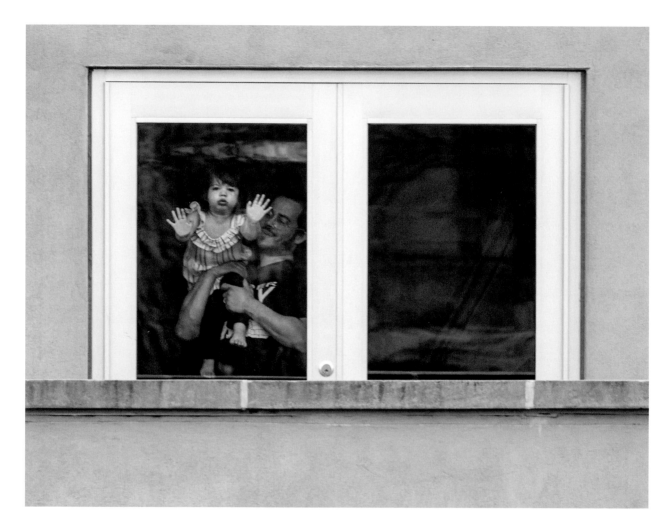

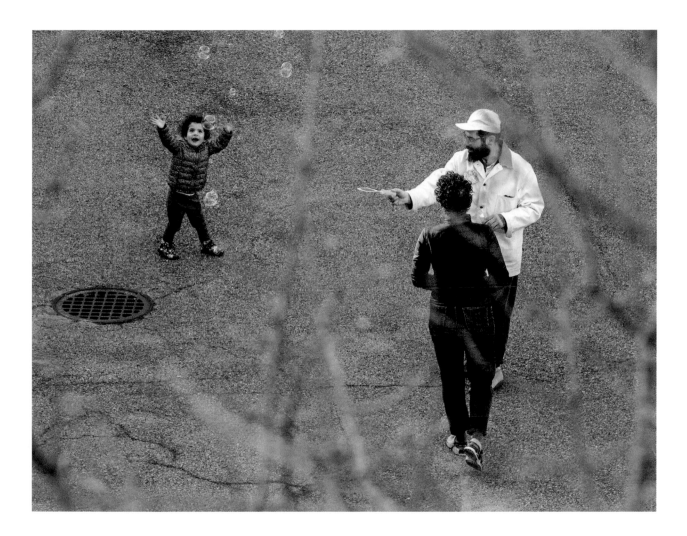

This family has access to a parking lot next to their building, giving
their toddler a spacious blacktop for bubble blowing. With
help from dad, some extra bubbles reached a toddler on a terrace
five stories above, making for a socially distanced playdate.
I think we're all desperate for any playdate we can get right now.

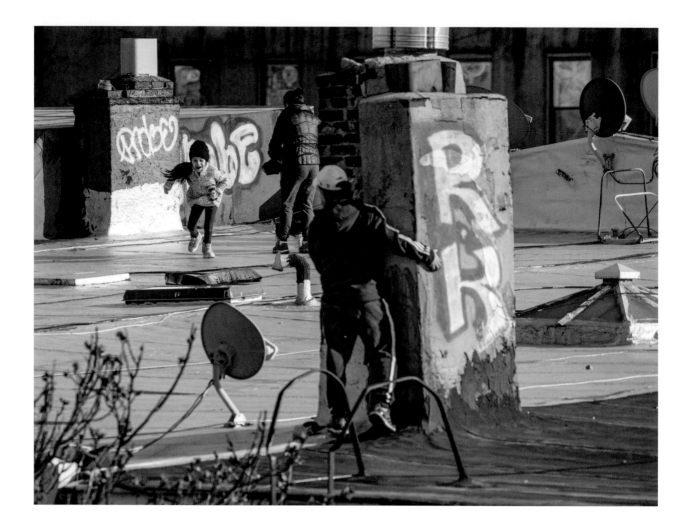

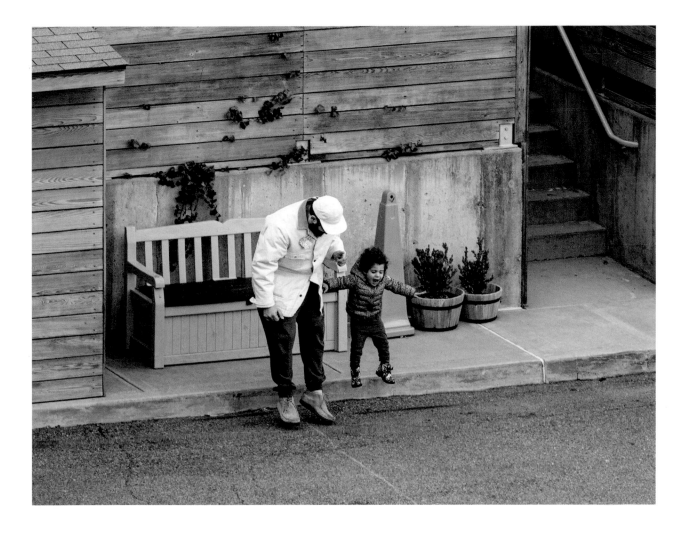

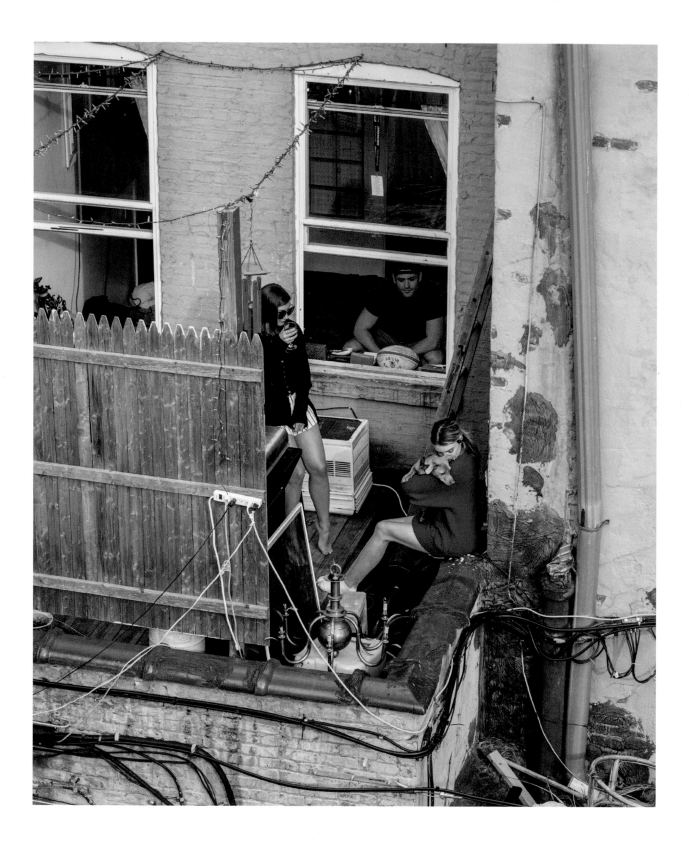

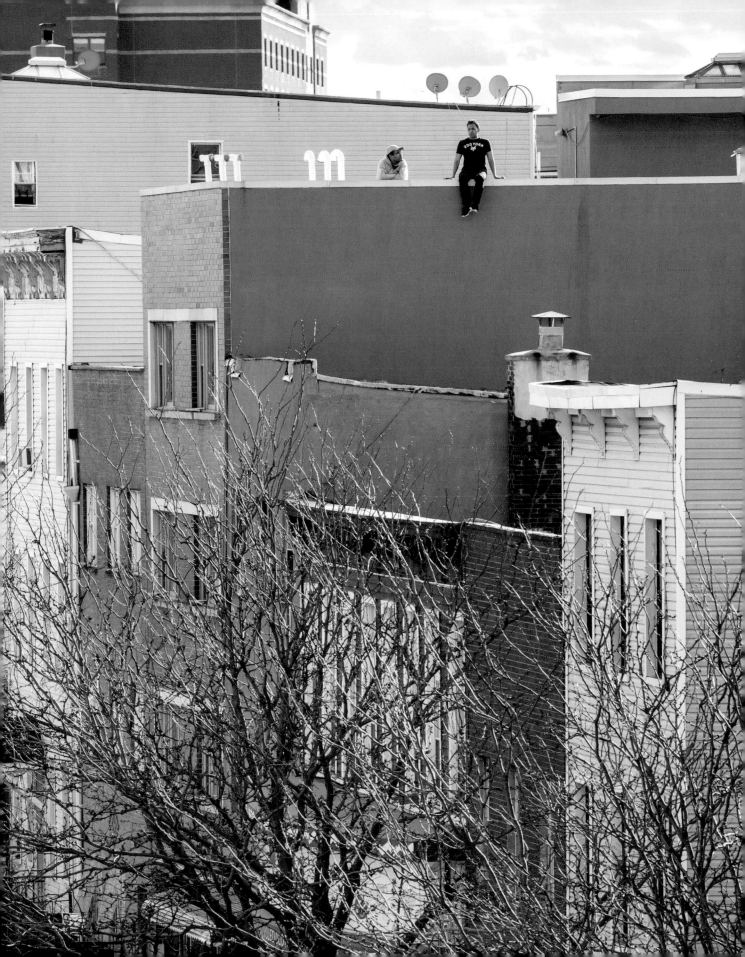

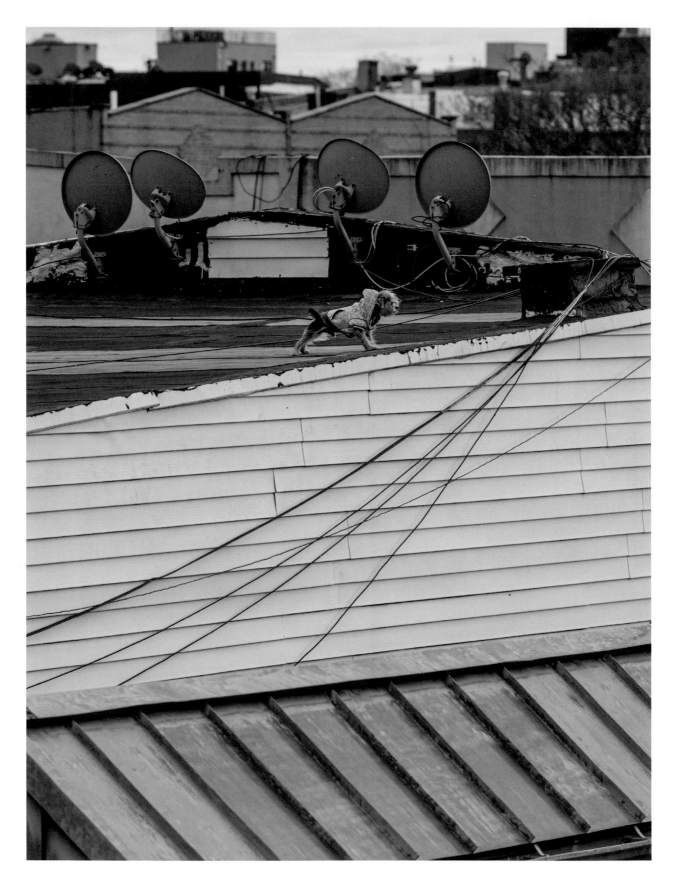

OFF THE LEASH (APRIL 2)

This dog is off the leash!

After weeks of being walked around the roof in small circles, Horus has been granted the freedom to explore. It was terrifying to watch him inspect the perimeter, sniffing and curiously peering over each edge. Within the hour, he was joyously prancing around the roof, his boundaries well-calibrated.

It's been a harsh three weeks of quarantine with no end in sight, so we're all feeling a bit off the leash.

JOURNEY TO THE ROOF (APRIL 8)

Every person has a different journey to the roof. Some have swanky elevators with "roof deck" buttons, some have rickety fire escape ladders, and some climb out of a window and make quite the introduction.*

The safety of the roof plays a massive role in how its quarantine culture will develop. An effortless elevator ride to a roof protected by sturdy guardrails makes it an obvious destination for picnicking, painting, playing instruments, and babies.

Most buildings in my neighborhood require climbing a sketchy ladder to an unmanicured rooftop that was never intended to provide anything more than shelter. No guardrails exist—just a flat drop—making the roof a dangerous place to visit. Children, the elderly, and anyone afraid of heights probably won't be coming up.

Those confident enough to make the trip have to plan strategically, packing supplies into backpacks or totes for the climb. Packing the right amount of beers means an easy trip up and an easy trip down. That said, on even the most perilous ascents, I've seen elaborate barbecues—grill and all—hauled up via graceful assembly lines.

What my roof lacks in ease of access, it makes up for in space, character, and a wonderfully diverse crowd of people. Living in a strip of rowhouses with a shared roof creates a sense of camaraderie that I suspect seldom exists among the secluded, upscale roof deck button-pushers.

Leslie triple confirmed I have permission to feature this upcoming image.

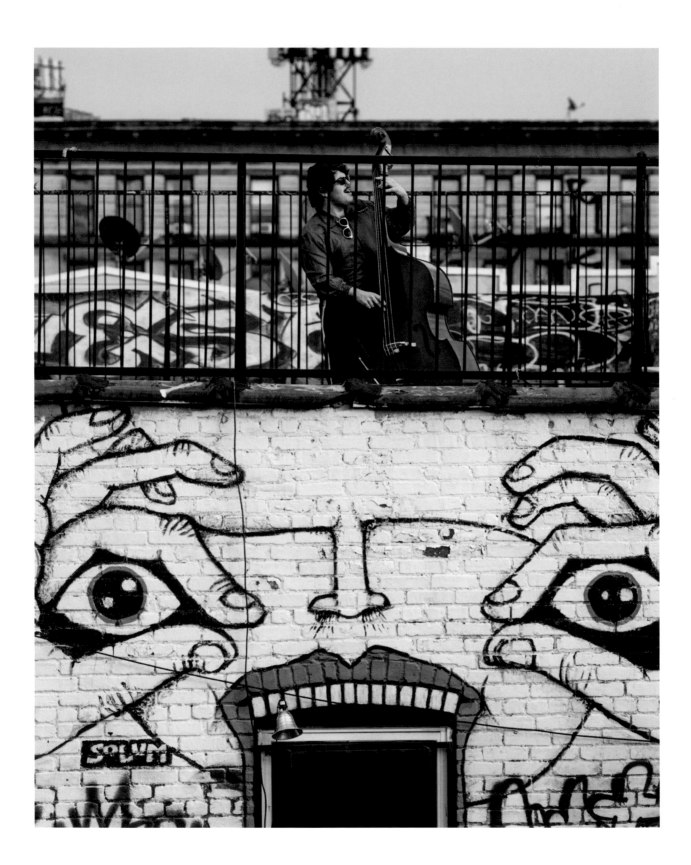

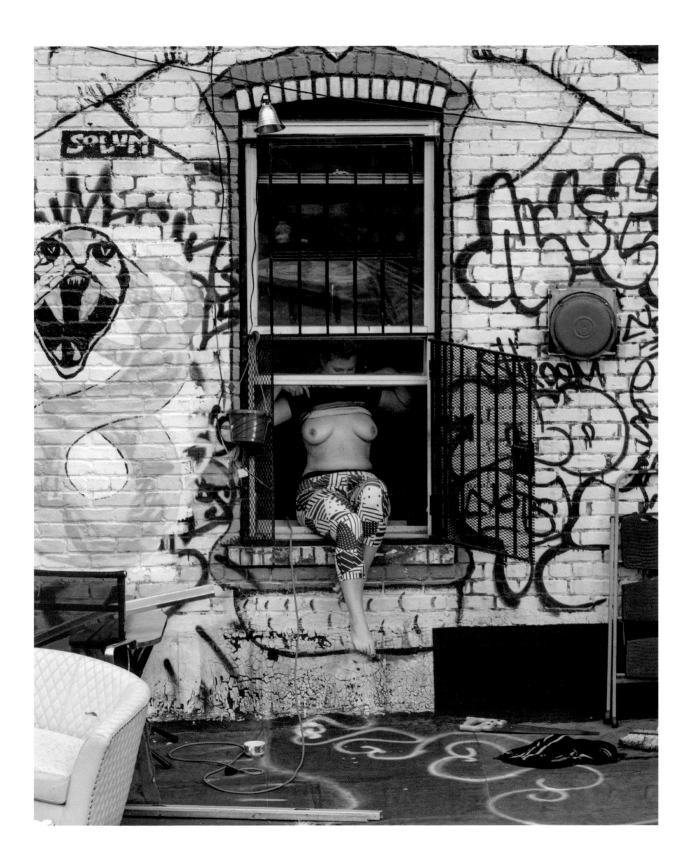

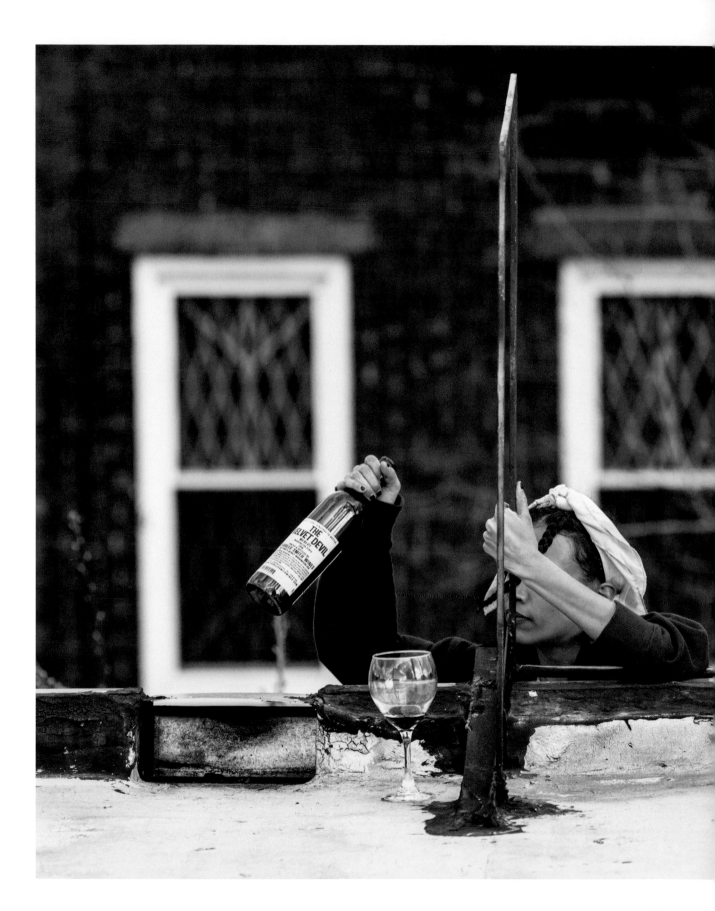

PERSONAL RITUAL (April 12)

As my neighbors settle into their rooftop routines, I've formed my own ritual in striving to capture the pulse of the neighborhood.

At the beginning, battling constant FOMO, I would climb to the roof to check for action every few hours. I even considered running an extension cord to create a rooftop office but decided that I needed the occasional break from my day job.

Now, I climb the ladder no later than 5 p.m. on weekdays and 10 a.m. on weekends, which is when most of my neighbors emerge. I begin by greeting the binocular-clad pigeon fanciers, who act as my personal rooftop scouts, alerting me to any important happenings such as attractive sunbathers or rogue hawks. I proceed to make the rounds, methodically walking our 17 interconnected rooftops, saluting all the regulars.

This process could take five minutes or an hour, depending on who's outside. The unemployed tanners love to chat, the Airpod exercisers refuse to notice me, and the blank gazers are thrilled to break the monotony. Whenever I encounter someone new, depending on the distance between us, I either introduce myself and the project or just wave enthusiastically with my camera. I photograph everything I see: each new person, behavior, or activity, no matter how mundane, because together these images tell the story of a newly developing community.

When conversation runs dry, I either share beers and stories with the pigeon fanciers, carry my speaker into a new corner to pass the time dancing and gazing into the distance, or write down whatever is on my mind. Whatever I'm doing, my camera is in hand and I'm constantly scouting, ready to photograph anything that catches my eye. My neighbors have come to respect my devotion to this project; they understand that I'll run off mid-conversation if I spot something I need to capture. Many have even begun serving as my informants, providing extra pairs of eyes on the roof. I used to bring a book, but never found a quiet moment.

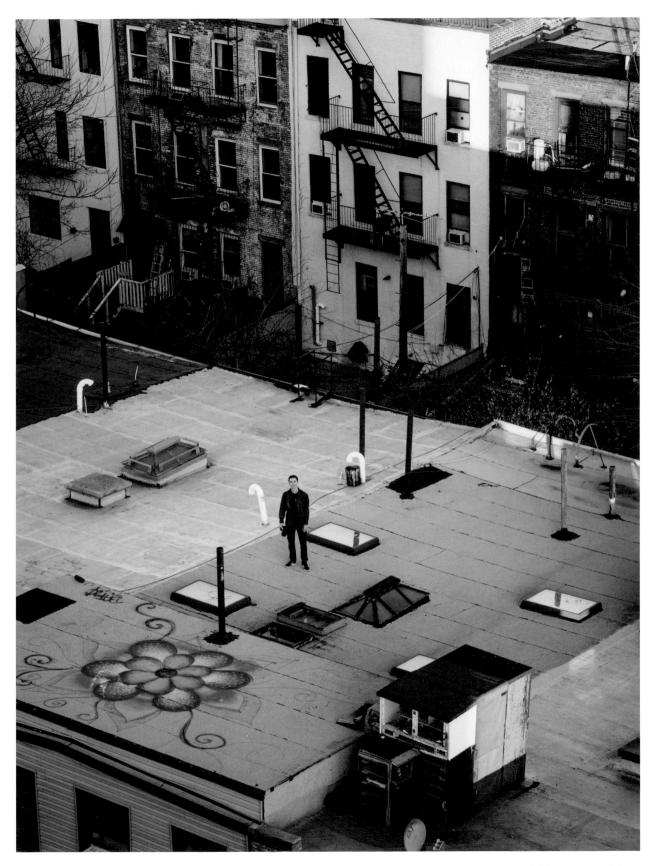

My neighbor, Jeremy Cohen,
shot this portrait of me.

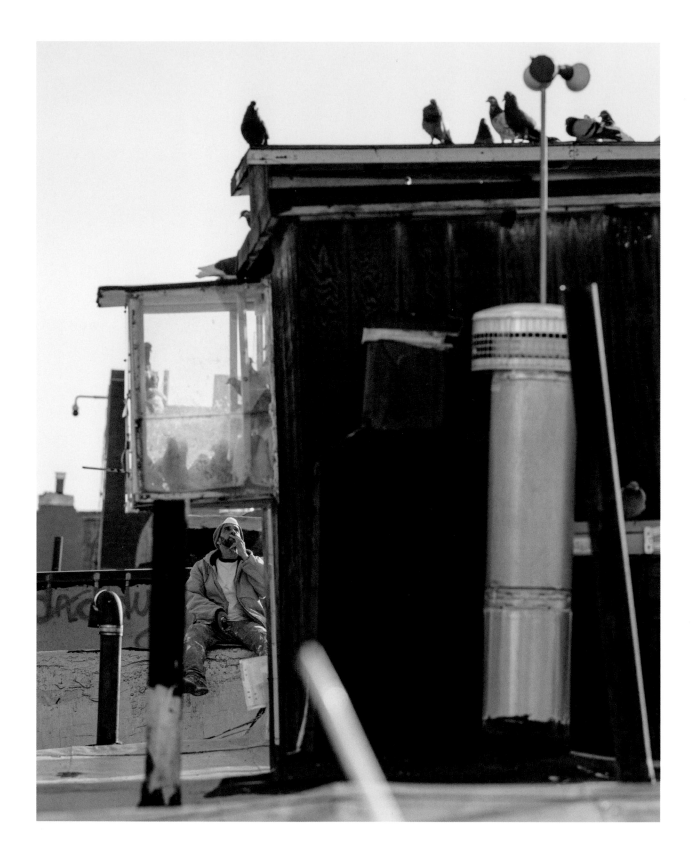

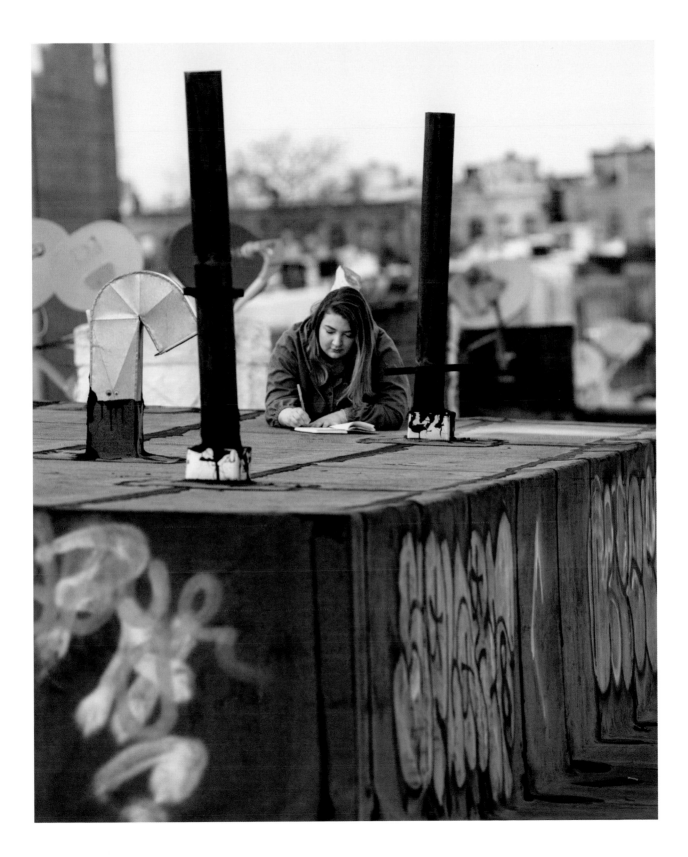

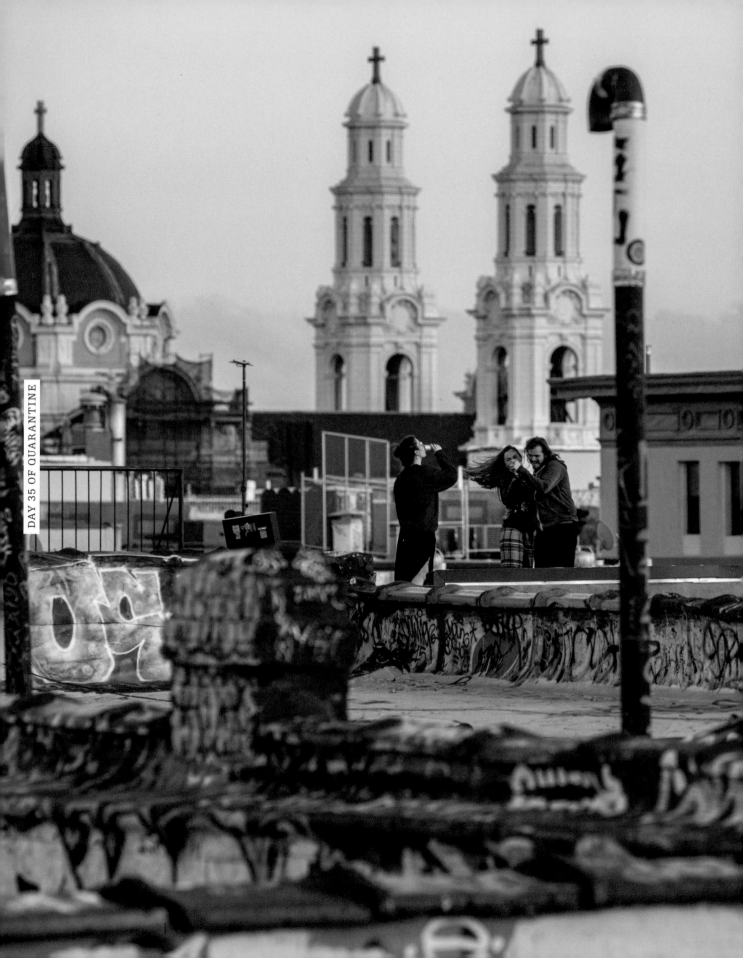

IMPORTANCE OF IMBIBING (APRIL 16)

Everyone is looking for ways to break up the monotony, confined to the same place with the same people doing the same things. Many neighbors are forming a ritual of coming up to the roof for the 7 p.m. city-wide clap for frontline workers, often lingering to appreciate a sunset over the city skyline.

People often drink beers or smoke, which is easy to chalk up to boredom. However, as the days blend together, these casual indulgences become more meaningful. They become the demarcation between work and leisure, the essential button that triggers relaxation.

The standard work-from-home advice is to get dressed for the office to create a mental separation between work and leisure. A few drinks or a joint seem to be equally as effective. Of course, one could achieve the same effect with daily smoothies or yoga, but I'm just making observations here.

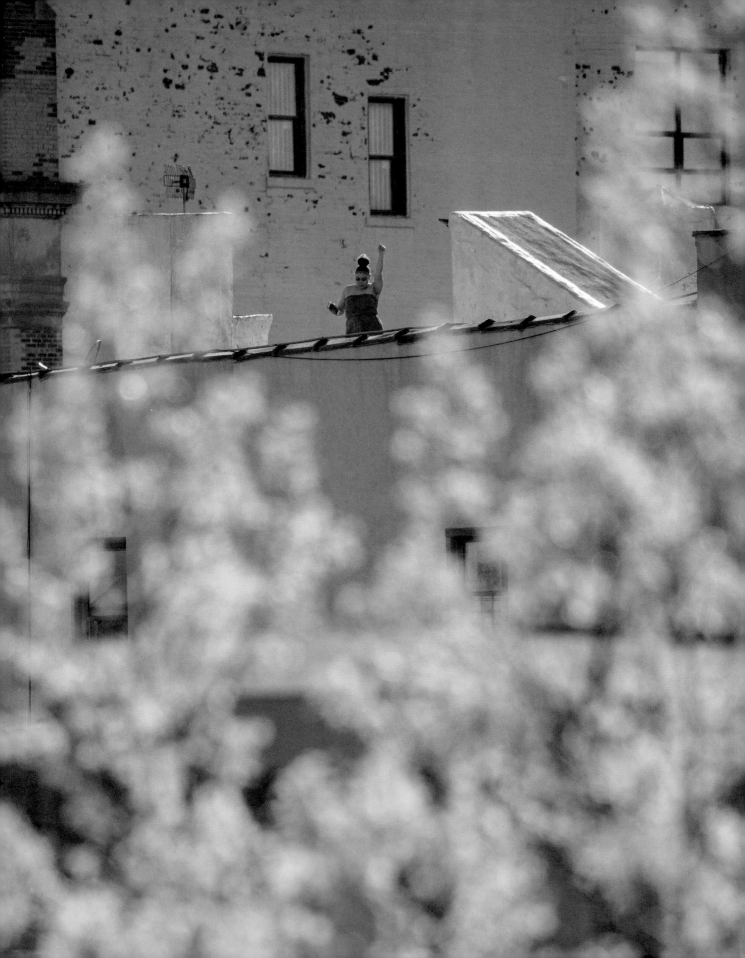

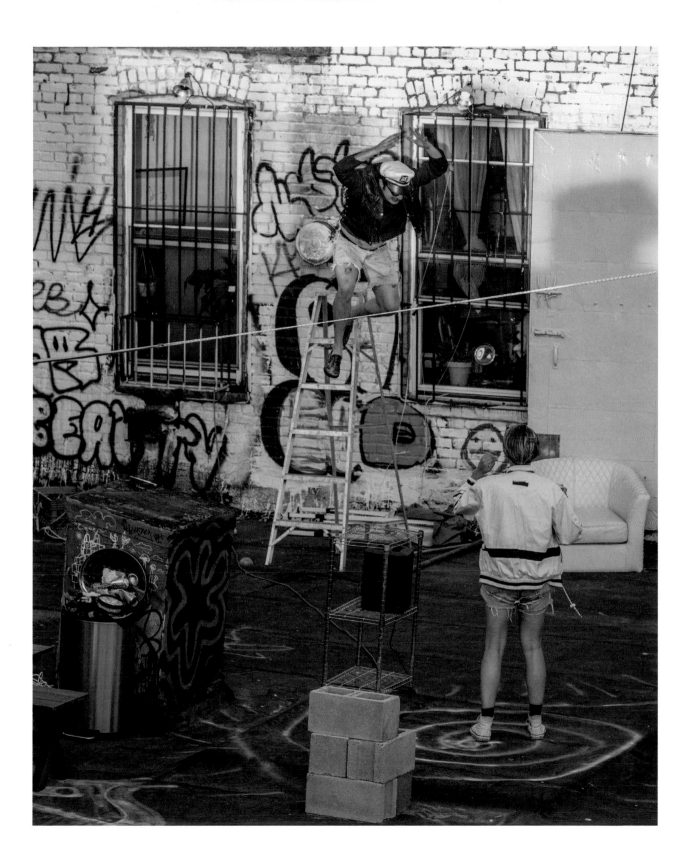

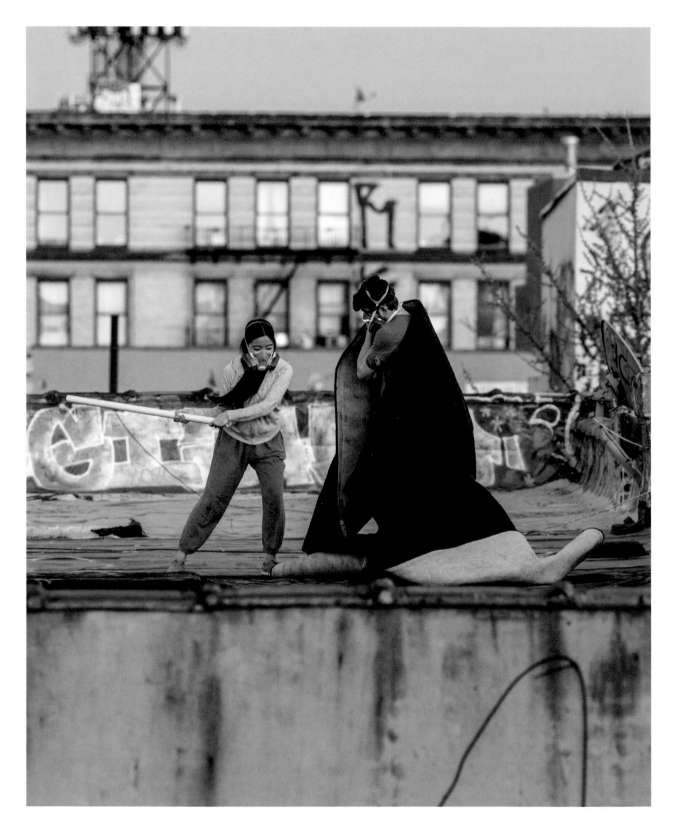

OUR DIFFERENT QUARANTINES (APRIL 19)

Quarantine means so many different things to each of us depending on our age, health, roommates, employment, paranoia, and feelings of invincibility. I've noticed people's rooftop behavior tends to reflect their situation.

There is so much we don't know. What's a reasonable risk? Will this next trip to the laundromat be my demise? Should I start doing my laundry in the bathtub? Under quarantine, every moment outside your home is an immeasurable risk.

No one knows where the roof fits into this equation of risk. Some neighbors only use the roof to hang laundry in an effort to avoid laundromats, always wearing protective masks. They, or any of their roommates, might be sick, elderly, or immunocompromised, so their trips tend to be minimal, quick, and full of palpable anxiety.

Other neighbors consider the rooftop a place of pure leisure, an extension of the home. Their lives revolve around the roof—socializing, exercising, and passing the time—often without a mask. While protective measures like social distancing are still taken, being young and healthy, surrounded by others in similar situations, affords a privileged risk.

A quiet rooftop is a beautiful respite, but an overpopulated one could be as dangerous as any public space.

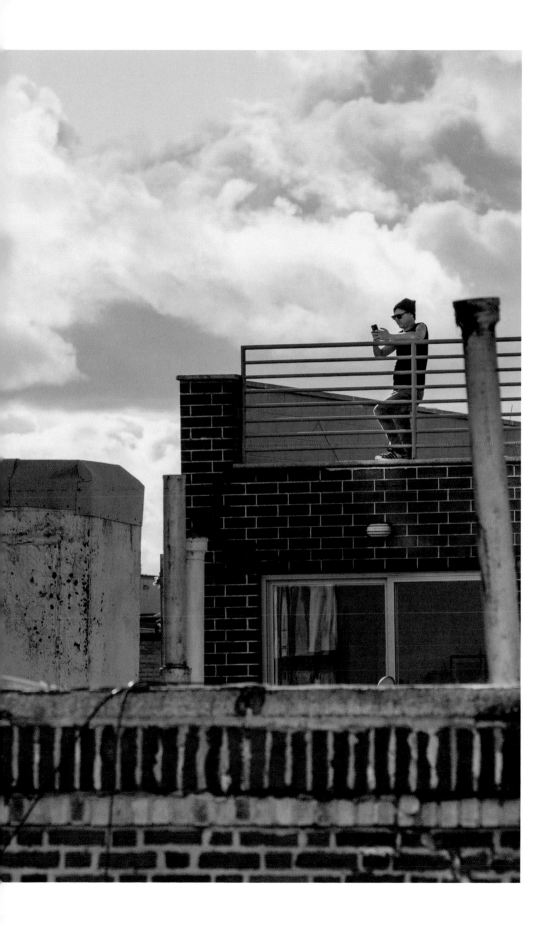

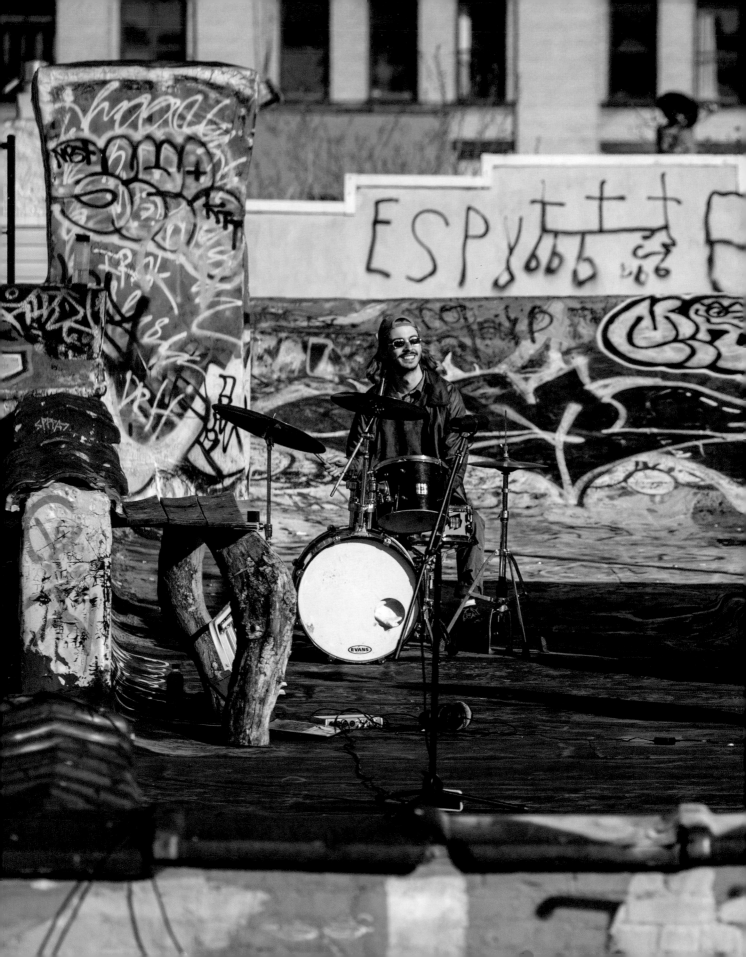

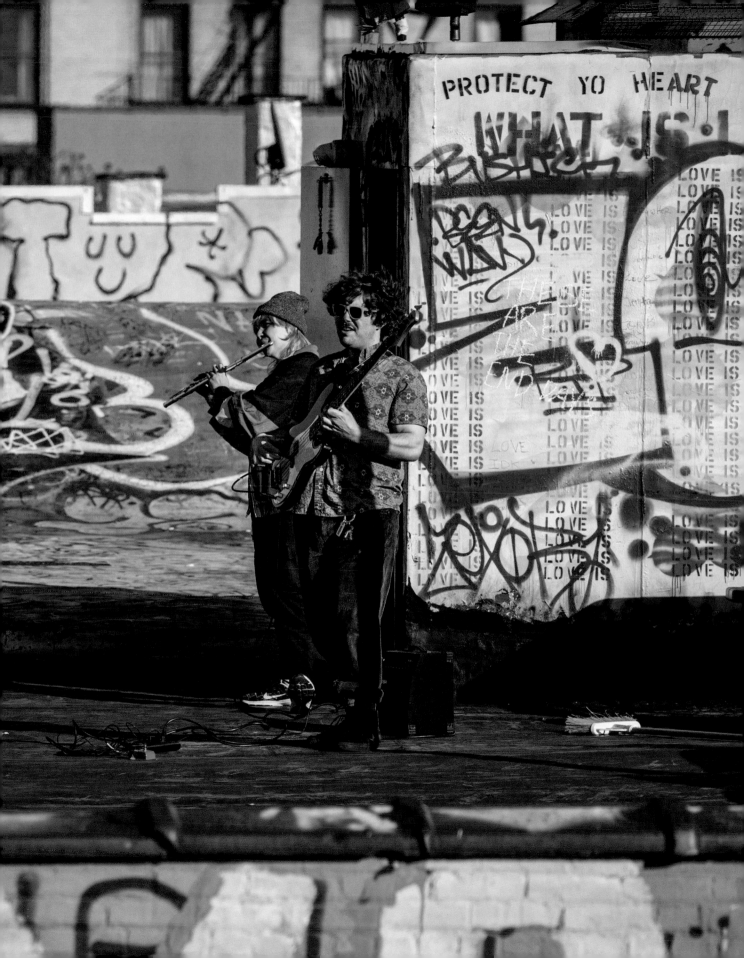

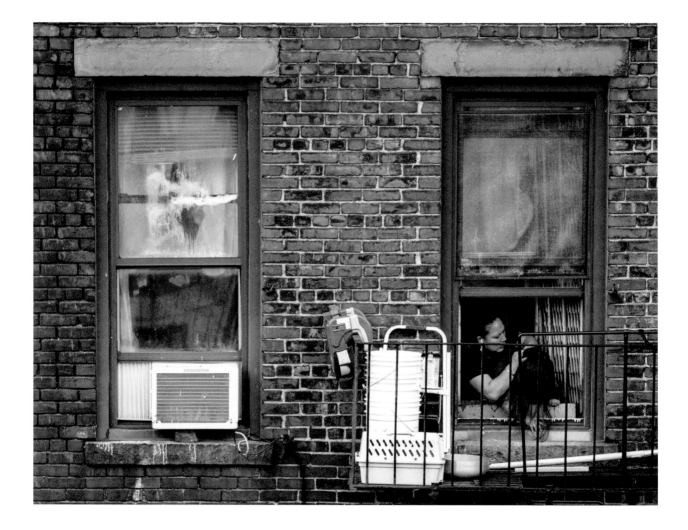

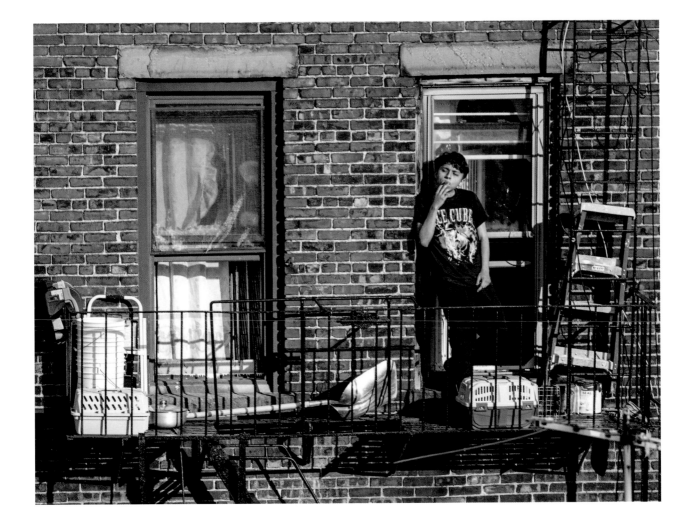

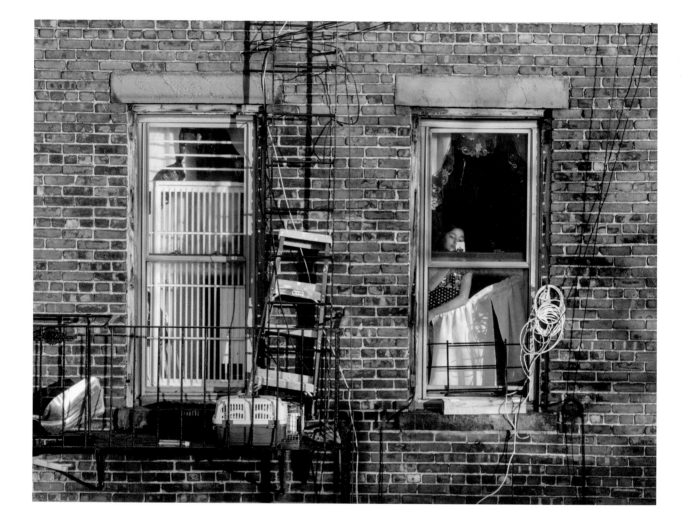

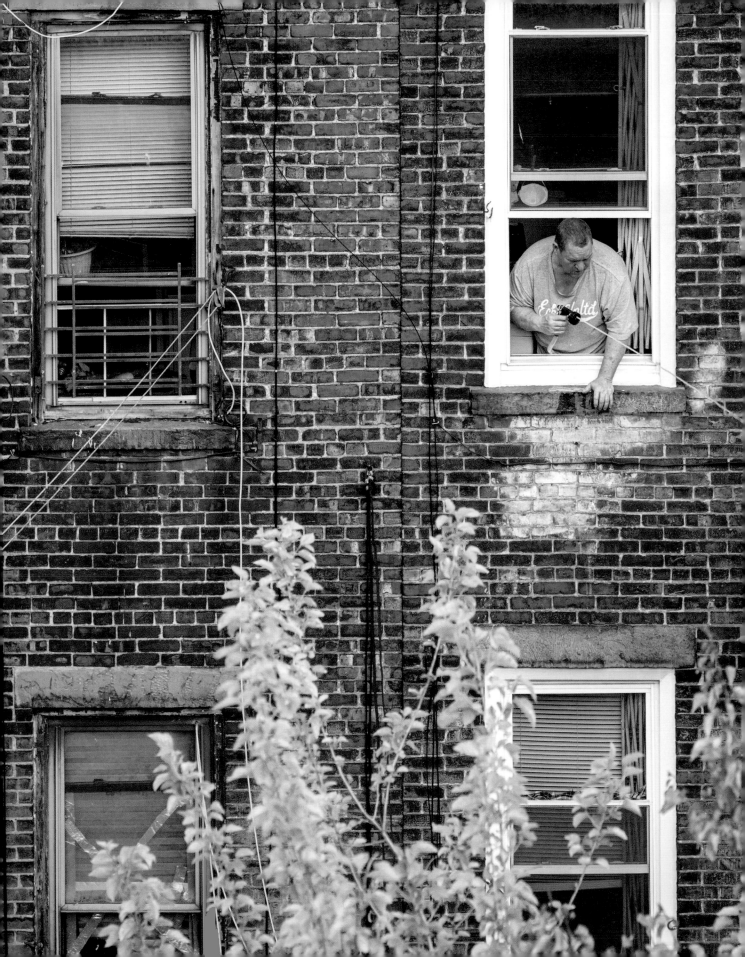

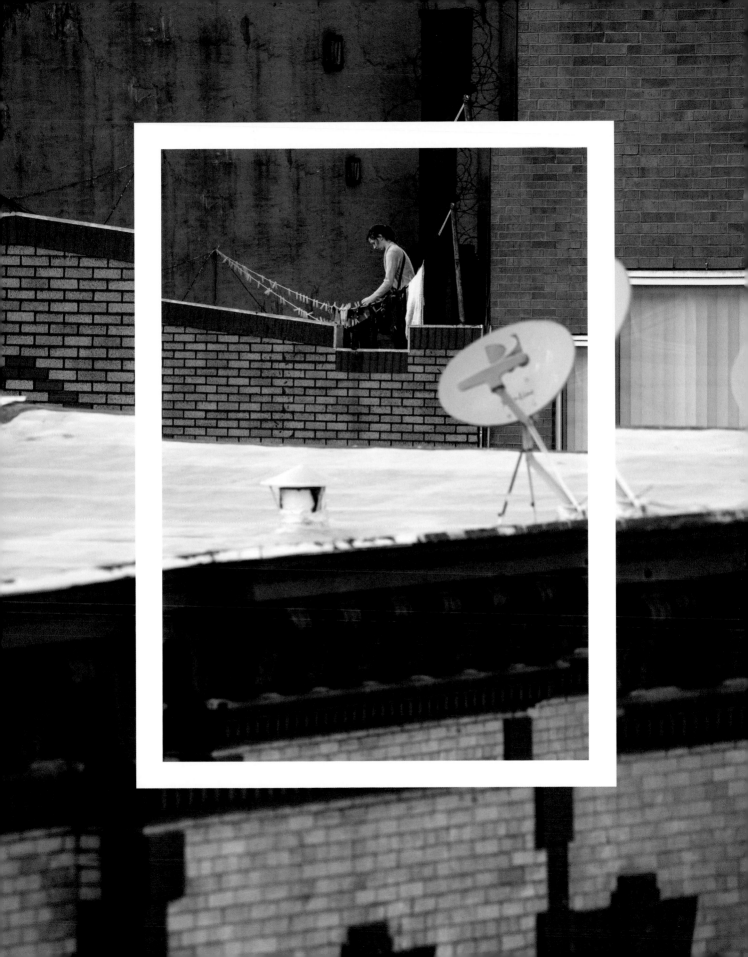

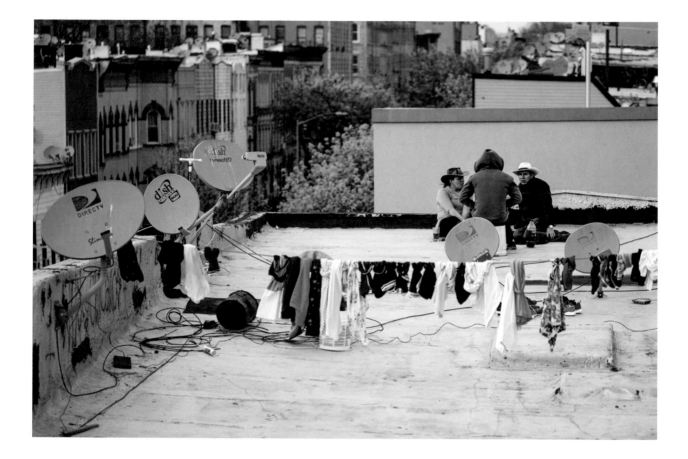

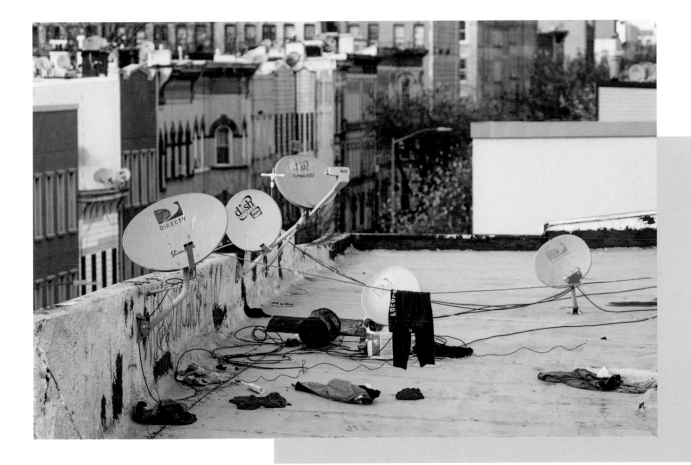

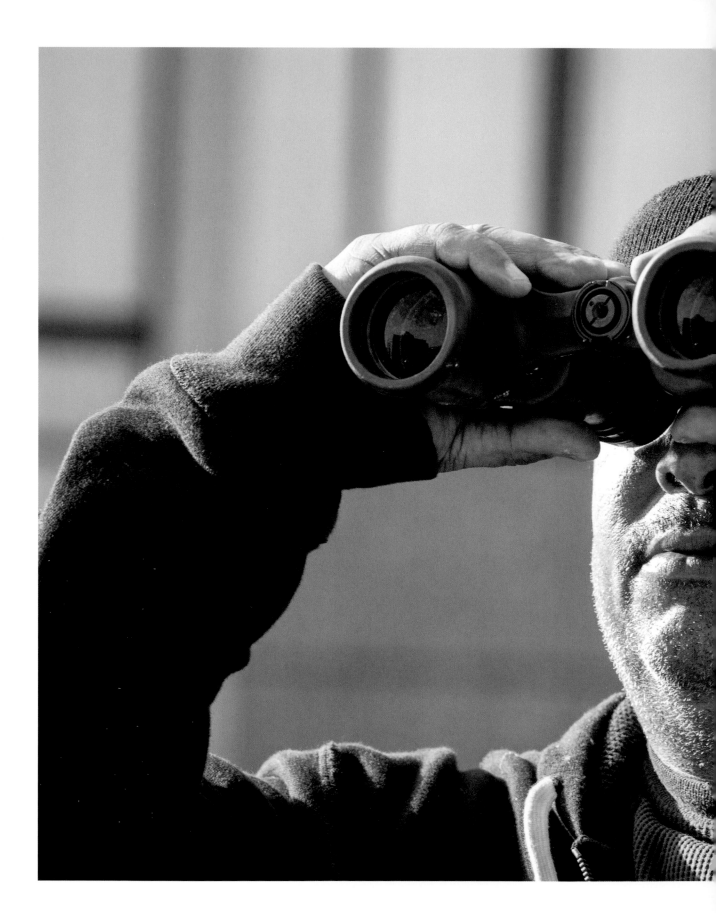

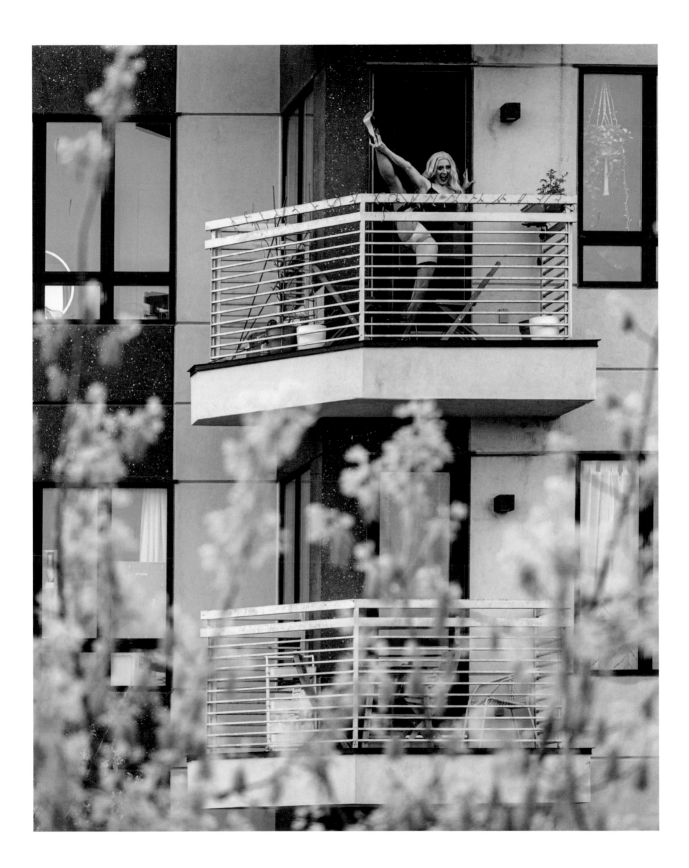

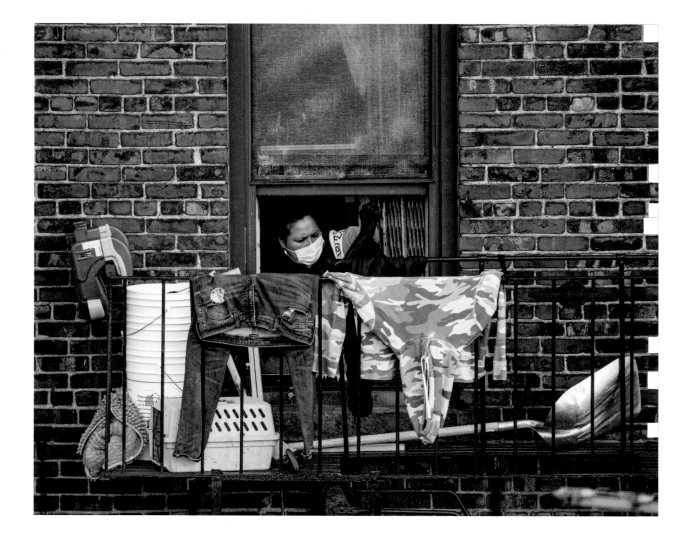

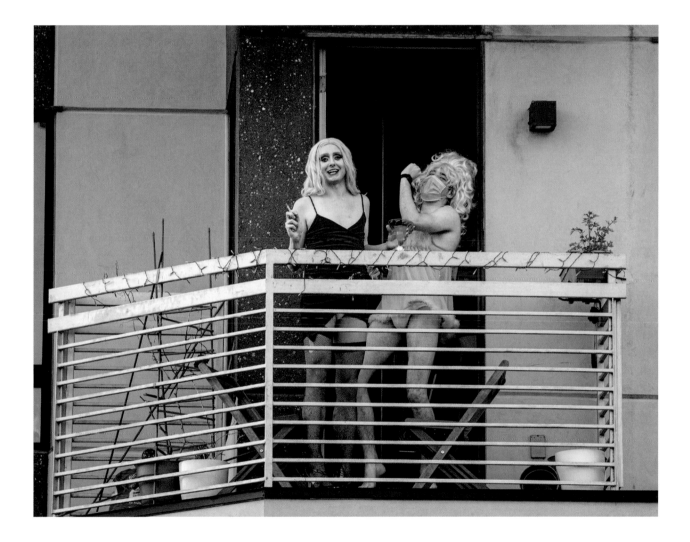

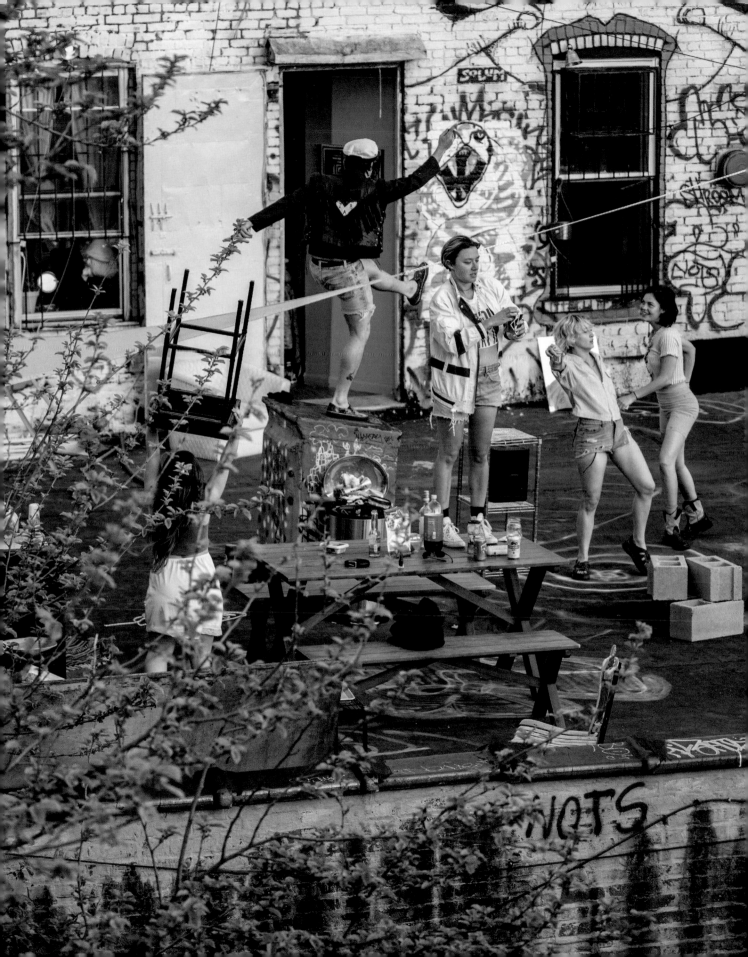

LOVESICK

Every developing relationship is a rickety bridge over a chasm of heartbreak, over which we hope to cross from singledom to a committed partnership on the other side. Under normal circumstances, we can cross at a safe pace, find alternative pathways, or turn around if the bridge feels unstable.

Just when I felt I had a grasp on dating, global lockdowns struck, jerking that bridge on every relationship and forcing couples around the world to choose which side to rush toward. Long-term relationships collapsed while two-week flings opted to quarantine together, jumping into domestic situations more intense than the average marriage.

This didn't go well for me, a very single guy.

After a second date in early March, I ambitiously pitched Low-Stakes Monogamy™—agreed-upon exclusivity without any expectation of long-term commitment—to maintain a responsible quarantine. She decided to move back with her family on Long Island, never returning my book on American megachurches.

When my roommate got sick before the city locked down, I regretfully cancelled a first date. I brashly called her to break the news, secretly hoping for a conversation to dispel my quarantine boredom.

She, too, had news for me, announcing a sudden emigration to Canada to rekindle an old flame before the border shut down. This is neither here nor there, but her old flame does live with his parents.

After jimmying off the hatch locks to access the roof, I knocked on some doors to share my discovery. This led to a brief fling with my upstairs neighbor. There's nothing more romantic than having a prolonged discussion about quarantine habits before mutually agreeing to violate social distancing standards. Needless to say, she eventually fled to her parents' home in the suburbs.

Recognizing the universality of peculiar quarantine romance, I invited people on Instagram to share their own stories. With permission from everyone who submitted, I am dedicating these pages to the beautiful, shocking, hysterical, and tragic romances of 2020.

I found myself at the end of a long term relationship. We quarantined together until it became too much. I finally gained the courage to leave. And now I'm in a relationship with myself. It's the best relationship I've been in yet!

I entered a relationship a week after COVID started, partially because I really liked him, partially because I was scared of being alone. The fear of being alone drives us to give everything up to someone, because what else do we have during a pandemic? Honestly, I've been feeling so much better about myself, I felt like I was imprisoned in his views, and the feeling of freedom is so much better than the feeling of losing yourself in a relationship.

I got married during Covid ☺ Our first date was cancelled and then when we finally did it, none of my family could be there. It was very last minute and a bit unexpected.

We were in our first few months of dating when quarantine hit, he was super super careful covid wise, and realized that he didn't think it was safe for us to be in contact. We would meet on my front porch every day, six feet apart. He would bring his folding chair and I would sit on the steps. After we realized this wasn't necessary, I decided never to take for granted the importance of physical touch.

We are long distance until Australian borders open again... whenever that may be.

When I moved to Brooklyn at the end of 2019 I was looking for an available room, so I responded to a Craigslist ad, met the guy and ended up taking over his lease and moving into his old room. In the few months after meeting him we kept seeing each other and caught feelings. We started dating right when the pandemic hit. So... he moved in with me! (Right back into his old room!) A year later we are still happily dating and living together.

I met someone who lived in the same building as me!!

I matched with a girl on Tinder, I liked her vibe, and our conversation flowed pretty naturally. We had a FaceTime date over beers—I was on my roof, she was out in her backyard, on a day with lovely weather, and it went well! We had 5-6 more FaceTime dates since that one, and being so early on in the pandemic, it was extremely refreshing to have someone to talk to, and felt even better to have a crush on someone. Unbeknownst to me when we matched, she actually lived an hour north from the city, but had vague plans to move to the city for grad school which is why her location was set to NYC and we matched in the first place. Anyways, I had a car, I had a crush on her, so I decided to take the drive up to meet her. I wasn't doing much else. Her dad was an older guy with some pre-existing condition, so we settled on having a socially distanced date in her hometown. We had beers and listened to music in her backyard, walked around her town, all at 6ft apart, and then I drove back home. After that, we had many conversations trying to calculate and figure out how we could hook up without killing her father (via testing, quarantines, etc). Ultimately, we decided it wasn't really possible without quarantining for 2 weeks pre- or post-hookup, which neither of us were willing to do. She actually DID move to the city eventually, we had a few more in-person dates and were able to break social distancing since she didn't live with her dad anymore, but ultimately it fizzled out because we weren't all that compatible after all.

The defining moment for us was a video call that lasted 12 hours. From that point onwards, every single day (even right now as I write this to you) we have video called and the love has grown ferociously on both ends. We also love each other but we can't actually say it because we are waiting to do so in person, since it's not something that's said lightly. Our work around for this is a Spanish word called "Toma," which gets quite the workout when we talk to each other.

She lives in SF and I live in NYC. We matched on Tinder in April 2020. We very quickly went from Tinder to Snapchat and finally to text. Started talking every single day (scattered messages and snaps throughout the day), but that quickly turned into nonstop messaging. We then had our first FaceTime date after a few weeks of talking. Continued to talk for a few months. In late June, maybe early July, I sent her a message saying I wanted to stop talking because it was getting too serious for me and I was NOT getting into a long distance relationship. We went our separate ways for 1 week. I then messaged her saying I missed her. We started talking again with no clear sight of where this was headed. In late August or early September, we told each other "I love you" before ever meeting.

We matched on Tinder after the app made it possible to swipe over long distances for a while. Long story short: we matched, we were in daily contact and sometimes we spent all day together in a Zoom call. In July he was able to come visit me, and we ended up spending two full weeks together and officially became a couple. I have been in Norway since shortly before New Year's Eve and have more or less been living at his place since.

I sat at home alone. It was a blast. Love yourself.

We started dating in the beginning of February. My first serious college boyfriend. Pandemic started and I couldn't go home, so his family invited me to move in with them. We've lived together ever since.

I met this girl on MySpace way back in 2006 when we were both in 6th grade. I'm from New York and she's from San Francisco. We've never met in person. She tells me she's visiting some family of hers in Orangeburg (NY) for the first time and asks if we should finally meet up. That was back in late December of 2020. So she's standing there by the fountain across the street from the Apple store on 59th and 5th avenue, and I'm standing across the street. She doesn't see me. As I'm about to walk over to her, I freeze. I feel as though I can't catch my breath. My knees feel like soggy french fries. I turned my phone off. I tightened my knees as hard as I could and started walking in the opposite direction. We haven't spoken since then.

I started playing Minecraft again for the first time since middle school and formed a group of some old friends (one of whom was an old gf) to play with. We'd get on a big FaceTime call and play until 4am every chance we got. Long story short, I realized I still had feelings for my middle school girlfriend of all people, and we reconnected. We've been dating for almost a year now.

But then one of those seemingly meaningless swipes was Ariana.

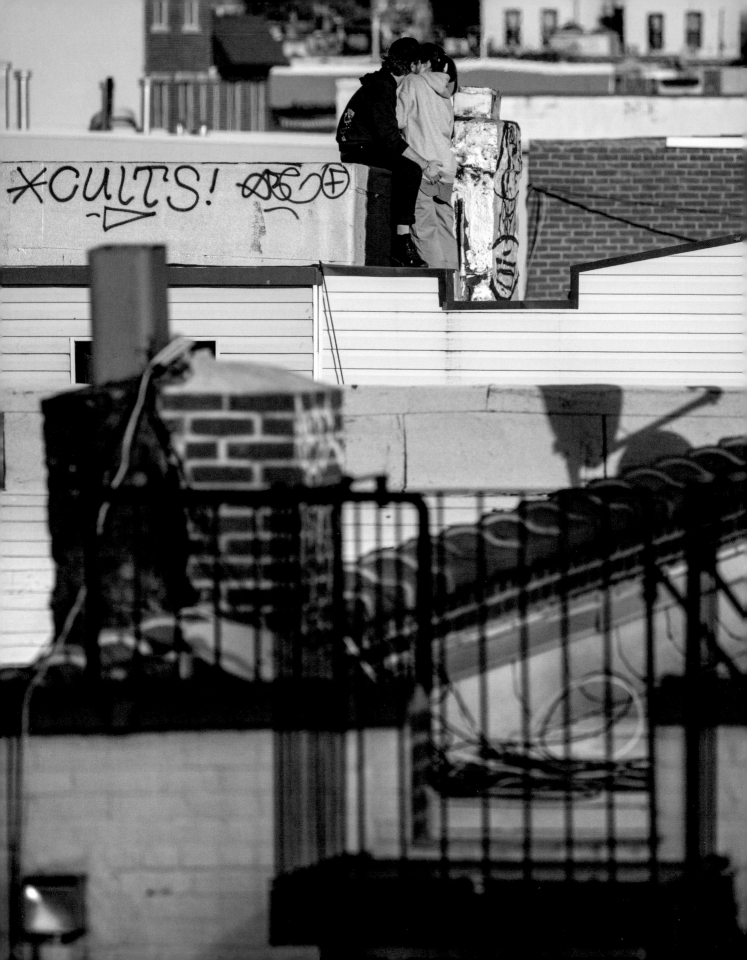

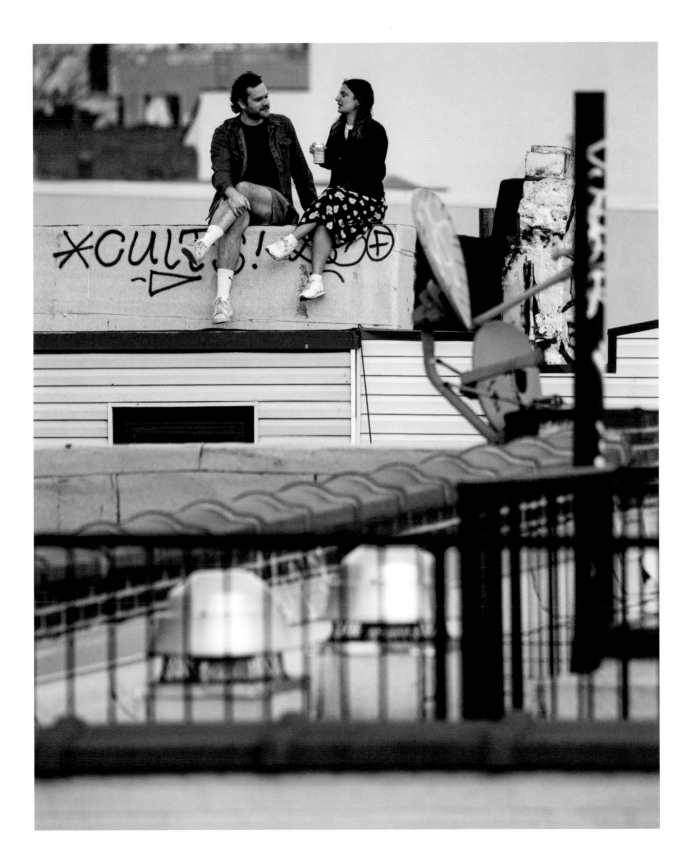

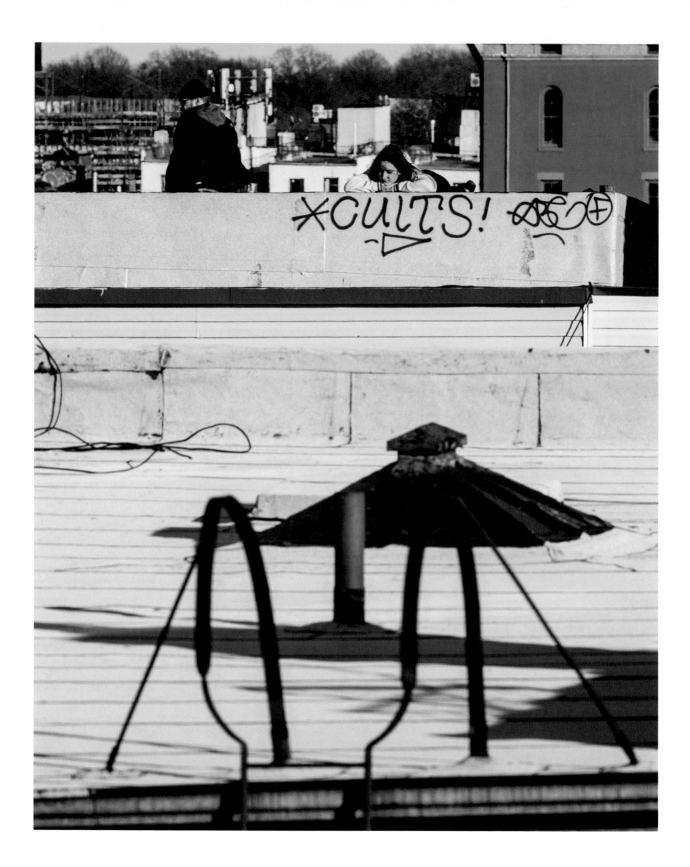

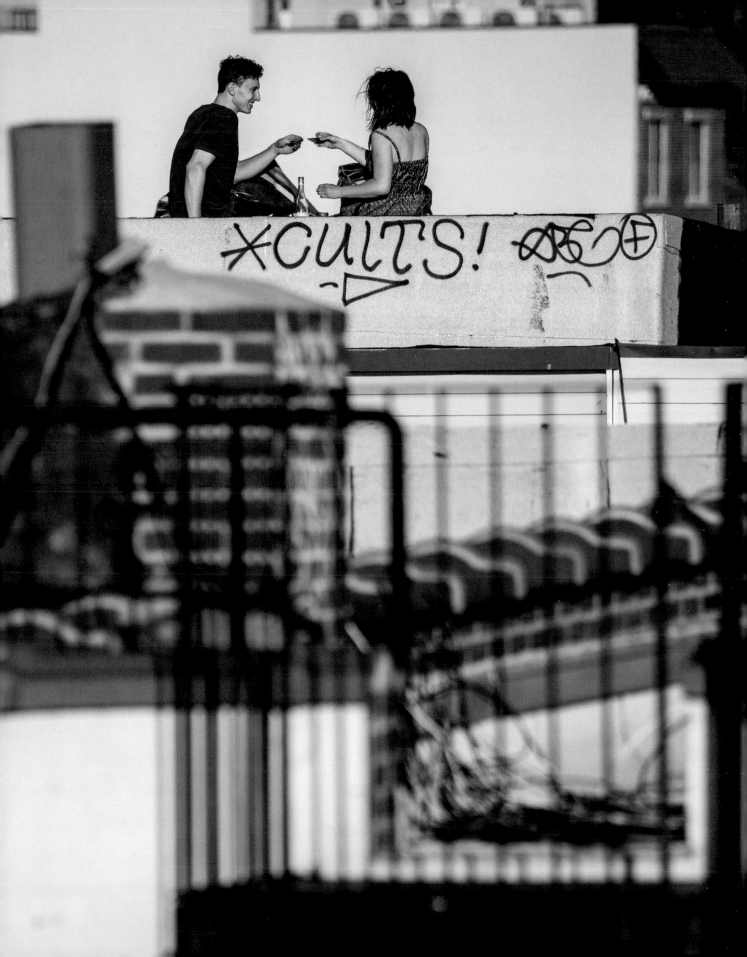

SOURDOUGH STARTER (APRIL 20)

Once Americans got past panic-buying toilet paper and hand sanitizer, a new wave of items began flying off the virtual shelves. Yoga mats, puzzles, painting kits, yeast, and hair trimmers quickly became hot commodities, backordered into oblivion. These suddenly elusive items tell the story of our collective quarantine consciousness, straddling a line between creativity and desperate boredom.

In quarantine, artists* are going through a wide range of creative directions. Our shared pessimism about a world completely disrupted and optimism for rebuilding it, exacerbated by isolation and its creative limitations, is enough to spawn a lifetime of creativity. I've curiously observed artists pivoting, reinventing, furiously creating, and, sometimes, taking a pause.

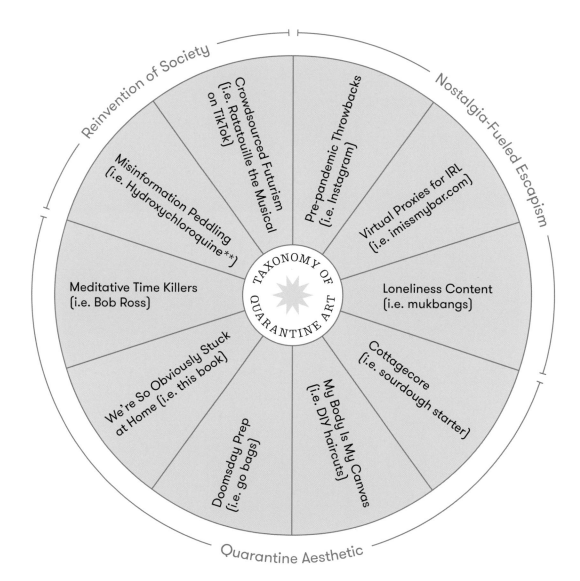

Reinvention of Society

Nostalgia-Fueled Escapism

Crowdsourced Futurism
(i.e. Ratatouille the Musical on TikTok)

Pre-pandemic Throwbacks
(i.e. Instagram)

Misinformation Peddling
(i.e. Hydroxychloroquine**)

Virtual Proxies for IRL
(i.e. imissmybar.com)

TAXONOMY OF QUARANTINE ART

Meditative Time Killers
(i.e. Bob Ross)

Loneliness Content
(i.e. mukbangs)

We're So Obviously Stuck at Home (i.e. this book)

Cottagecore
(i.e. sourdough starter)

Doomsday Prep
(i.e. go bags)

My Body Is My Canvas
(i.e. DIY haircuts)

Quarantine Aesthetic

This pie chart is my attempt at pinpointing the creative consciousness of artists in quarantine.

*I use this term loosely since everyone and
 their grandmother has become an artist in
 lockdown (which is a beautiful thing).

**I can't help but acknowledge the creativity
 in admittedly malicious propaganda.

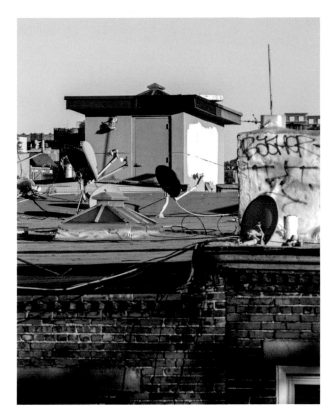

OCTOBER 2020 UPDATE
This piece has been covered.

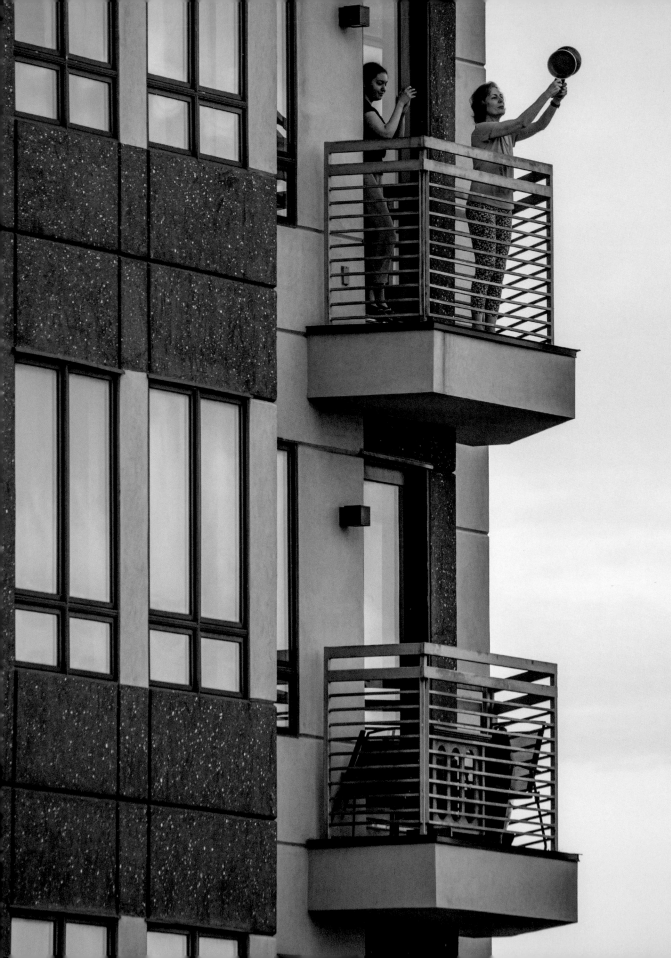

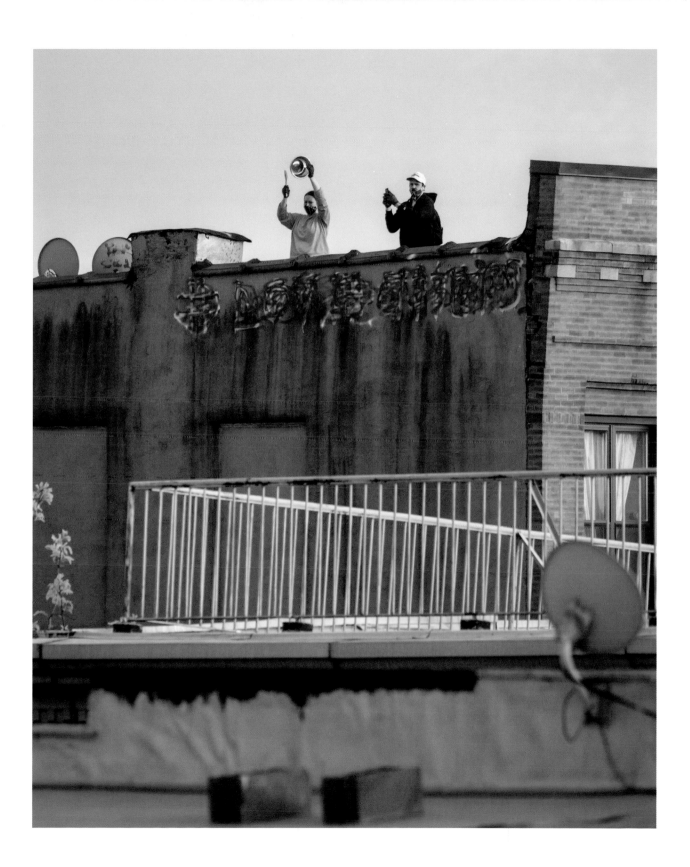

FOUR-PHASE THEORY (APRIL 23)

For the last 42 days of quarantine, Marco has graciously allowed me to photograph his family's progression on their rooftop. From what I've observed, there are four distinct phases in the evolution of people's relationship with the roof.

Phase 1: Scouting Since most of the roofs in my neighborhood are not easily accessible, people rarely visited them before quarantine. Many discover the social scene after weeks of being cooped up with no outside contact. For the first two weeks of quarantine, I see new people popping up every day. They cautiously take a seat far from the unguarded edge, look around, and possibly stay for sunset. The first time I see Marco, he's walking his dog while his brother-in-law does push-ups.

Phase 2: Sharing These pioneers convince their roommates and neighbors to visit the roof, turning it into an outing. The new visitors are still getting acquainted with the space's possibilities, so their behavior is tame, often starting with picnics. After two weeks, Marco's wife and kids appear on the roof for the first time. His young daughter still requires help climbing down, but I suspect this won't last for much longer.

Phase 3: Experimentation Everyone tries to make the space their own, testing its boundaries by inching closer to the edge and trying new activities. At this stage, I observe Marco and his family flying kites, playing hide & seek, and romantically spinning their dog in circles.

Phase 4: Normalization After the experimentation phase, the roof loses its novelty, and routines begin to form. The roof becomes less a destination and more an extension of the home. Forty-two days in, I think Marco's family is still in the experimentation phase, treating the roof like a family activity. His wife and daughter have yet to form autonomous relationships with the roof.

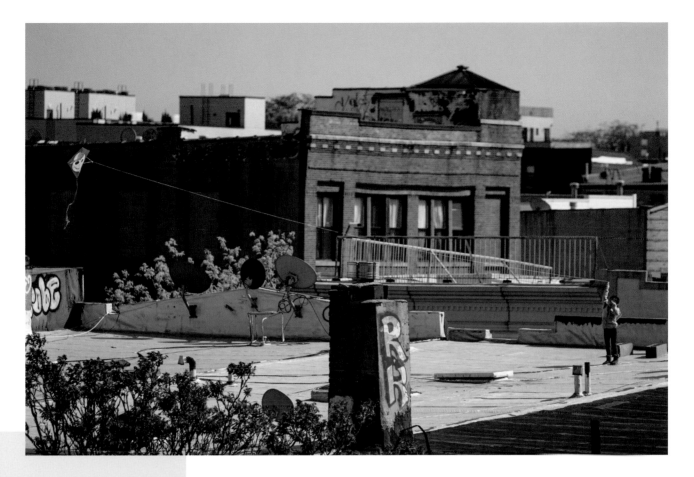

POSTSCRIPT

This series existed online before it became a book, and I shared photos to thousands of followers on Instagram. While I'd texted Marco for permission to write about his family, I was nervous to see his reaction to this intimate analysis of their behavior posted to social media. Fortunately, he loved the piece and proposed that we share a bottle of wine at his new restaurant once possible.

I learned that this is Marco's business from the ground up; he designed the spot, built it himself, and he cooks the food. After decades of dreaming and hard work, Marco was finally ready for the grand opening in March 2020. Then, the pandemic struck.

With the opening delayed, Marco bided his time on the roof. Come May, when he accepted that takeout and delivery were the only options for business, Marco added upscale Mexican dishes to his seafood menu because fresh oysters don't travel.

Around this time, I came by to photograph his menu and interiors, pro bono, to help out with marketing. After the shoot, we finally got to share a drink together as we sat down to my first restaurant meal since quarantine began.

If you're looking for delicious homemade Mexican food or fresh oysters, I highly recommend The Royal Seafood Bar at 160 Havemeyer St. in Williamsburg, Brooklyn. Tell Marco I sent you!

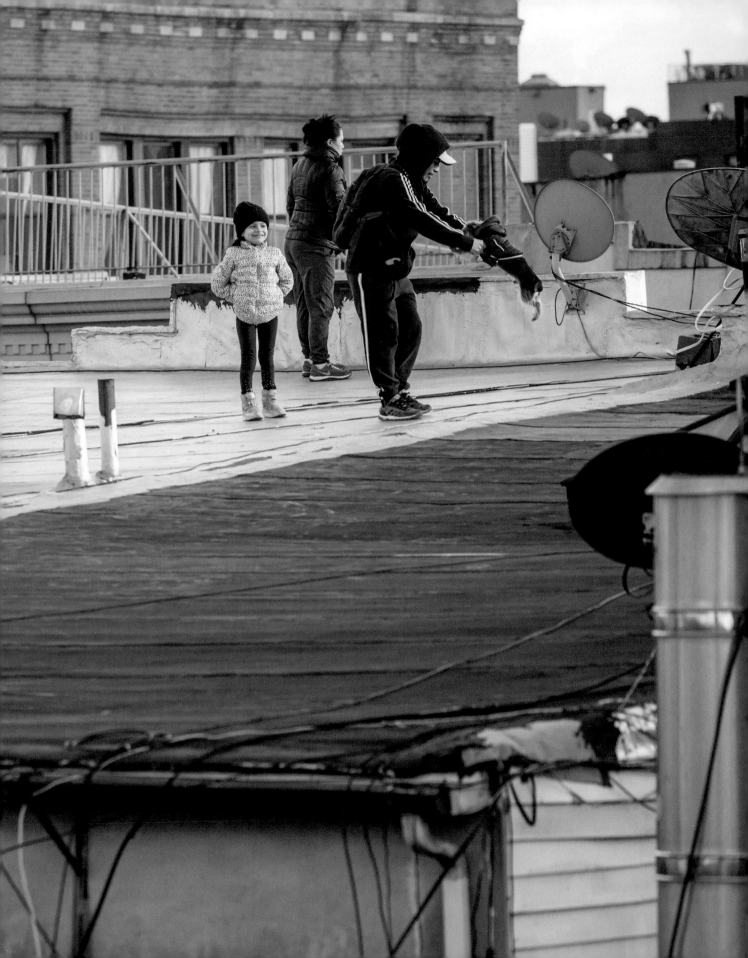

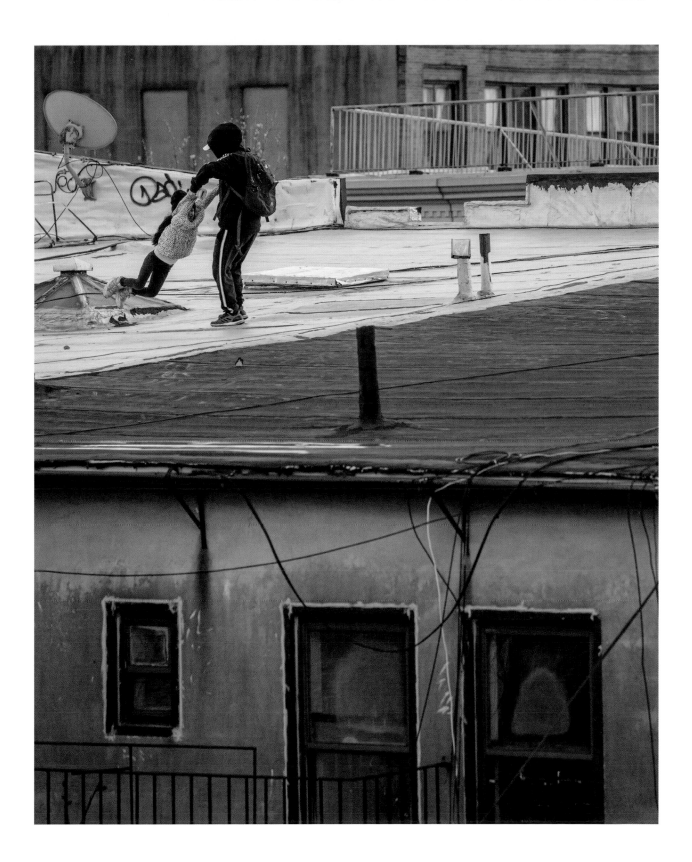

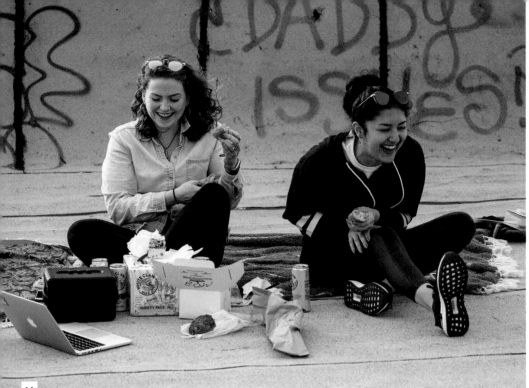

QUARANTINE BIRTHDAY (APRIL 25)

While birthdays tend to blur together over the years, full of the same annual traditions, quarantine birthdays are unforgettable. The limitations imposed on us force clever adaptations of old traditions and the invention of new ones. My 24th birthday was no exception.

My day began with friends and family surprising me with pastry deliveries. I felt warm as I answered the door to the strangers delivering these gifts. These underappreciated delivery drivers are the only remaining vehicle for tangible connection between folks in quarantine.

While birthdays can be logistically complex, I didn't have to send a single text to plan my celebration this year. I stuffed my camera bag full of pastries and climbed to the roof, knowing it would be a warm, lively Saturday.

Just as I'd hoped, my neighbors Katie and Tori emerged from an adjacent rooftop, and I invited them to eat cakes, pies, and breads, which we neatly divided between us to facilitate COVID-safe sharing. Coincidentally, two of my friends had planned their wedding for today. While, unsurprisingly, they had to postpone the big celebration, they decided to stick with this date for an intimate ceremony due to the unwavering demands of their love (and having already bought rings engraved with the date), which they'd broadcast on Zoom. This was the perfect entertainment to accompany our pastries.

Of the 50 virtual attendees, only one of my friends was bold enough to wear a tux in his living room. I've been obsessed with screenshot portraiture, so I captured some of the most exciting moments of the wedding. Just because our social lives have gone completely virtual doesn't mean we shouldn't be capturing cherished memories.

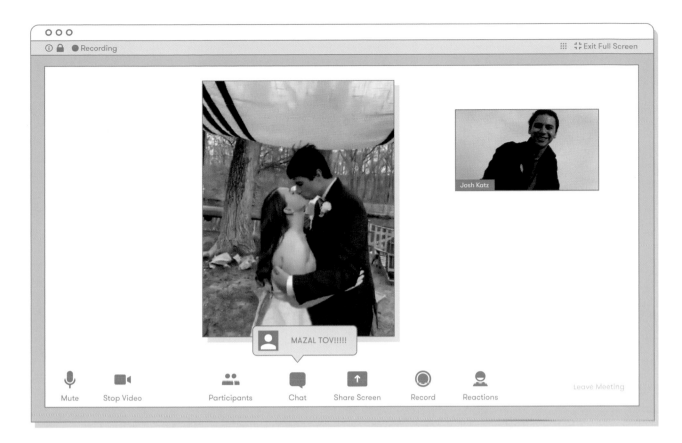

After the wedding, I noticed while strolling across the roof that an apartment across the street was covered in sparkly decorations and full of energy. Moments later, a fabulous lady in black stockings and the shortest red dress I've ever seen strutted onto the balcony to smoke a cigarette without a care in the world. After a few candid photos, I introduced myself and learned, to our mutual delight, that we were both celebrating our birthdays today. Katie and Tori joined the conversation, as did this lady's friend in a comparably scandalous outfit, and our collective joy turned the tiny balcony into a drag show runway as they embraced their characters with flair.

Some friends offered to organize a Zoom celebration, but I turned them down to spend more time on the roof with my neighbors. This might sound odd, but it felt very natural to me. The loneliness of the pandemic emphasizes a craving for interaction and intimacy that my computer can't provide. While Zoom is a fine communication tool, it's a poor replacement for being social, for making eye contact, for laughing, for dancing, for actually *being* with others.

I missed my friends, but I'll never forget my birthday in quarantine.

CODE OF ETHICS (APRIL 26)

I was surprised one day to be confronted by this canvas poised on a roof across from mine. I learned it had been painted to protest another photographer, who had been photographing our neighbors without their consent. While I've maintained a respectful and positive relationship with these neighbors, their protest forced me to recognize rooftop photography's inherently messy ethics, along with the importance of getting consent from each of my subjects.

The day after this protest, I created a code of ethics to share on Instagram, where I had been posting some of my photographs from the roof. Going forward, I shared this piece with every subject when I asked for permission to use their image. Giving control back to the subjects formed a mutual trust, a crucial ingredient for the success of this community-oriented project.

The following piece is an unrevised version of the original Instagram post.

This canvas was painted in protest of photos of residents that were taken without consent.

Documenting rooftop culture is a delicate task and what's appropriate isn't always black or white. Rooftops are in the public eye, but they're still a semi-private place connected with the home. I try having conversations with everyone I photograph within yelling's reach, briefing them on the project and asking for permission to share their image.

Many subjects are too far to communicate with and consent becomes tricky. If I can get their attention, I wave and point to my camera, relying on positive affirmation like smiles and reciprocal waves. Sometimes we communicate with unspoken games of "Simon says." But how long does the license to photograph someone last? Is it perpetual or just for a single photo?

Additionally, blasting these photos to a large audience over social media isn't what everyone expects when they have their photo taken by a random photographer. This may require another layer of consent.

This rooftop series isn't like traditional street photography where I'm capturing innocuous, fleeting moments of strangers. This is my local community, something I care deeply about, and I have a moral obligation to uphold. It also helps that I'll be seeing these people all over the neighborhood once this quarantine ends. Having an honest rapport and mutual respect is paramount to a healthy community and subsequently to this project.

I won't always be able to communicate with my more distant subjects. Unfortunately, there will be people who won't know their photos were taken until someone identifies them in a social media post of mine. To help navigate this moving forward, I've created a code of ethics for this project.

CODE OF ETHICS

1. I will ask for consent in every way possible. I may still shoot candids first, but won't sneak away without acknowledging my presence.

2. If someone's not comfortable with an image I've shared of them, I'll always honor their request to take it off social media.

3. Many neighbors have given me license to photograph them at any time. You're always welcome to walk this back if you change your mind.

4. I will try my best to represent the neighborhood in a positive, honest, and empathetic light. Ideally golden hour light.

5. I'll be the best neighbor possible, never taking for granted the delicate trust everyone has put in this project. Thank you ♥

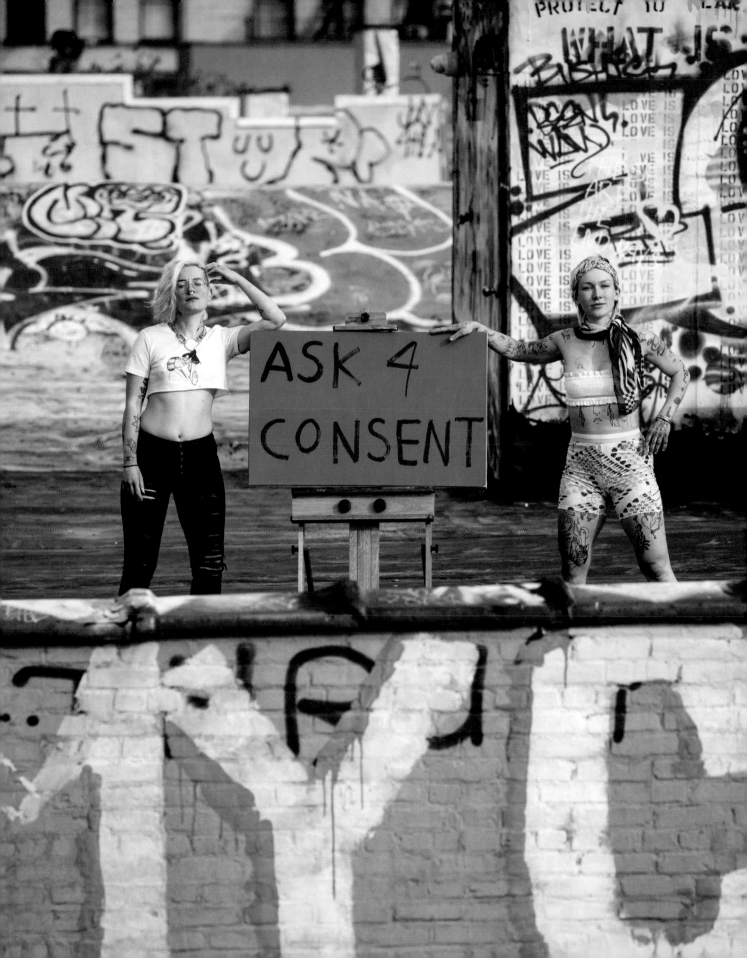

CONVERSING CROSS-ROOFTOP (APRIL 27)

During quarantine, cross-rooftop conversations have introduced a whole new set of social norms to navigate. These are a few of my favorites:

Lost in the Wind On a windy day, many conversations simply can't begin. On a wind-free day, I can chat with people two rooftops away. Often, I can only hear 80% of what the other person is saying, which is particularly interesting when it comes to making jokes—when someone doesn't laugh, I like to assume the humor was lost in the wind.

Reciprocal Repartee The closer we get, the quieter we can talk, so I've naturally developed "conversation spots" with neighbors on bordering rooftops where we're as close as possible. Every day, I casually greet all my neighbors, but both parties heading to the conversation spot is the unofficial signal for interest in a prolonged conversation.

This process can become an awkward dance. Heading to the established conversation spot, one must pay attention to the movement of their potential partner. When my movement is unreciprocated, it's akin to playing off a failed handshake. I use my camera as a crutch to pretend I was shooting something else.

Respectfully Eavesdropping When a conversation requires yelling, eavesdropping is inevitable from neighbors caught in the crosshairs. During normal times, conversational volume indicates if you're welcome to join it. Now it's all about context. Sometimes, I hear loud, juicy conversations but must restrain myself because I know my place.

Leaving Conversations with Nowhere to Go
Most of us have nowhere to go and nothing to do, so there's no easy exit from a conversation. It's typically a matter of saying, "well, this has run its course," in the most polite way possible. Yet, there's nowhere to go after the conversation ends, so you just have to look the other way. Awkward silences also do the trick.

Nonverbal Shenanigans When photographing someone who is beyond yelling distance, communication becomes limited to nonverbal gestures. I start with a wave to get their attention, and then I point to my camera and give a "thumbs up" sign. If my neighbor responds positively, I'll initiate a game of "follow the leader," seeing if they'll return a karate kick. This game has become dangerously intricate. While I don't recommend doing a handstand near an unguarded edge…I don't like to lose.

Despite these hurdles, I'll always prefer an awkward rooftop conversation to a Zoom call.

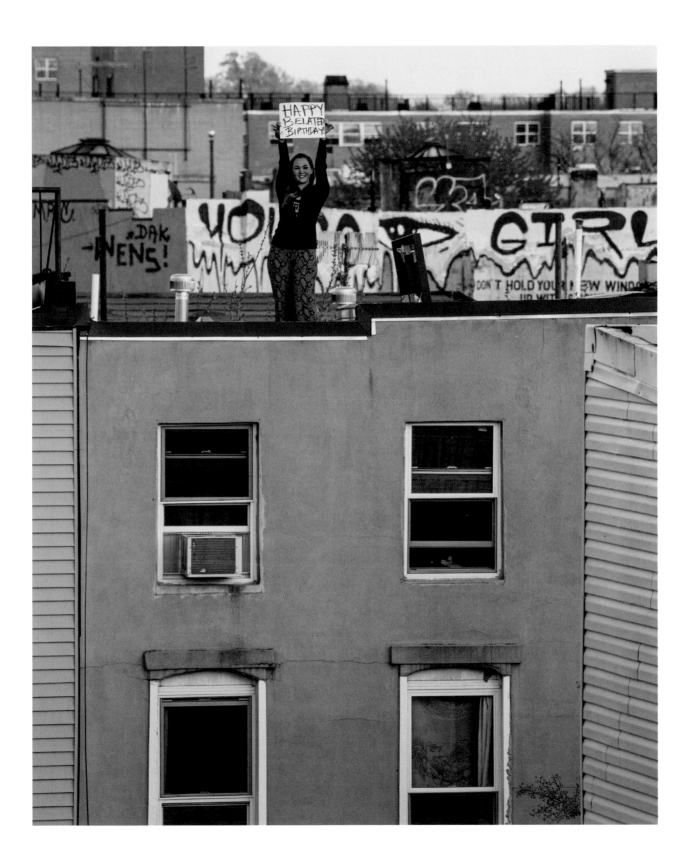

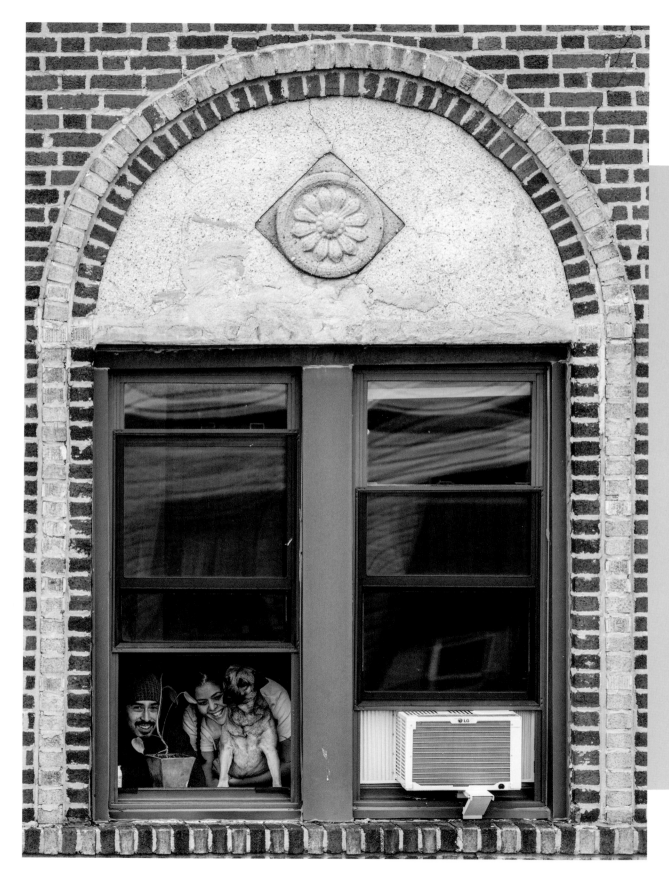

SELF-DEFEATING (MAY 3)

Does this series have a built-in expiration date? As more neighbors hear about the project and learn my rooftop lurking schedule, shots inevitably become less candid and more performative.

This series straddles a fine line between documentary and street photography. While almost all of the photos in this book are candid, each picture is more than an observation from behind the lens; it's an interaction. I blend into the background to capture genuine moments, but then I call attention to myself to be a friendly neighbor and ask for consent.

Normally, my street photographer's mind is desperate for candid authenticity. Yet, this loss of authenticity stems from relationships I'm building with my neighbors. Since this project is about documenting community, perhaps this is the ultimate gauge of success.

While I'm happy to shoot portraits for my new friends, I hope my camera becomes enough of a fixture that people forget it's there over time.

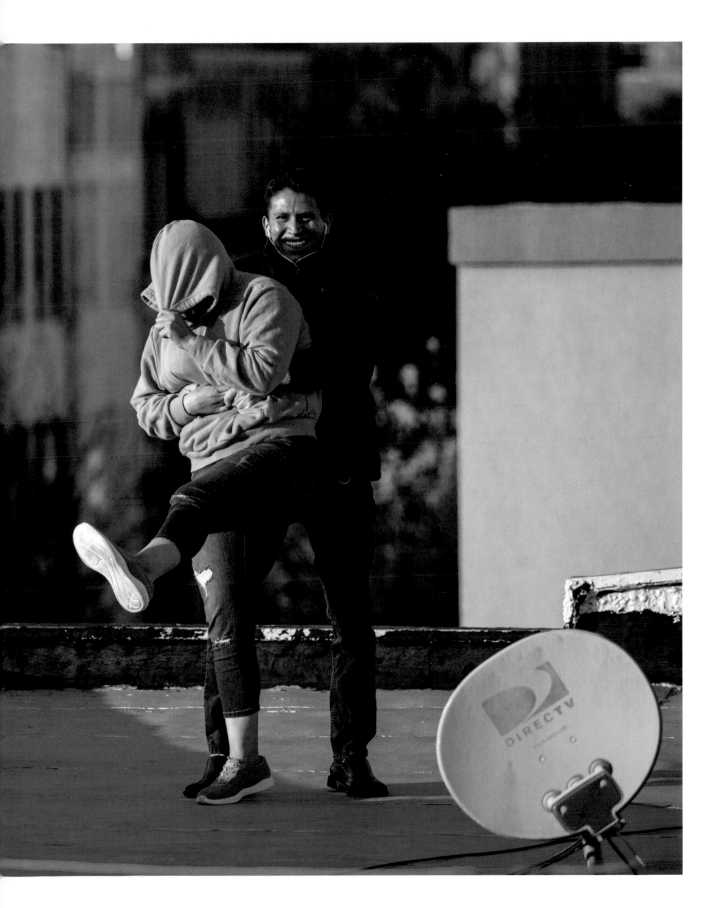

LESSONS FROM A FANCIER (MAY 9)

When envisioning a lifelong Brooklyn local, it's easy to picture someone jaded by gentrification. They miss the communal, family-centric spirit that has been uprooted by yuppie transplants who consider two years a long time to remain in an apartment. They're tired of great, community-owned businesses being replaced by sleek, overpriced coffee shops with outside investors. They yearn for the way their neighborhood used to be.

Gil, who's lived in the neighborhood all 52 years of his life, has seen Bushwick transform, yet he harbors no resentment. Instead, he's become a symbol of the neighborhood's resilience, the unofficial mayor of the block, the Pigeon King.

I see Gil everywhere. I see him on the roof every day, flying his 1,000 birds. I see him across the street, rebuilding the pigeon coop that was lost in a 2016 fire. I see him hanging out on the street, seemingly friends with everyone as he alternates between "What's up Papí," "How you doin'?," and his signature chop-busting. I see him leaning out his window across the street to keep an eye on the block.

I've even seen him in my own apartment. When I opened the door to my landlord and his painter, I was shocked and delighted to see Gil grinning back at me. My landlord was taken aback, "Oh, you two know each other?"

I first met Gil when I toured my apartment three years back and insisted on checking out the roof before putting in my application. Though I was still only a prospective tenant, someone he may never see again, Gil graciously gave me a tour of his coop, a small shack housing 1,000 pigeons. Since then, I've seen him welcome dozens of rooftop newcomers with the same hospitality and openness. When I ask him why he's so welcoming, he humbly explains that we all share the roof and it's about mutual respect. For a man who's spent thousands of hours making this roof his second home, he still treats it like a communal space to which we're all entitled.

Gil is a pillar of Bushwick. When asked about the effects of gentrification, he'll speak happily about the neighborhood's past and present. He reminisces about Bushwick in the 80s and 90s back when it was purely a Black, Puerto Rican, and Dominican enclave, and the rooftops were full of the liveliest parties he's ever seen. To hear him tell it, the neighborhood really changed post-9/11, when speculators began buying and gutting buildings, pushing out rent-controlled tenants and ushering in yuppies. He's had a lifelong affair with Bushwick, finding joy in its different variations. Things change, which he's come to expect, and he knows how to roll with the punches.

Gil's been dealt more than his fair share over the years, coping with the death of 2,800 birds in a 2016 fire, facing the incarceration of his son, and reckoning with all his old friends being "either dead or in jail." Through all of this, Gil knows how to rebuild. He rebuilt the pigeon coop across the street, working as the building's superintendent in exchange for access to the roof. He supports his son even when times are tough, sending him weekly care packages and providing money for the commissary. As a contractor, Gil keeps his work in the community, always hiring close friends and family.

He has personally looked out for me on so many occasions and always has my back on the roof: helping me negotiate with my landlord and keeping me abreast of the action, covering my rooftop hatch when I accidentally leave it open, and never failing to ask about my family. I wouldn't have spent so much time on the roof if it weren't for Gil's welcoming embrace, his mastery of the pigeon fancier craft, his Hennessy-fueled wisdom, and his friendship.

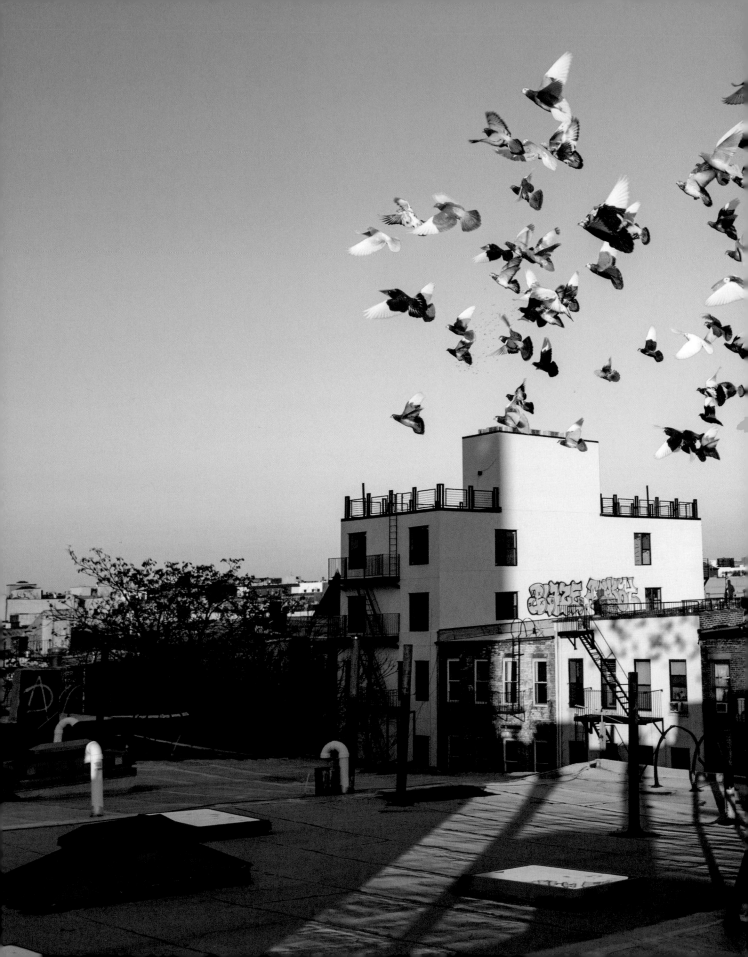

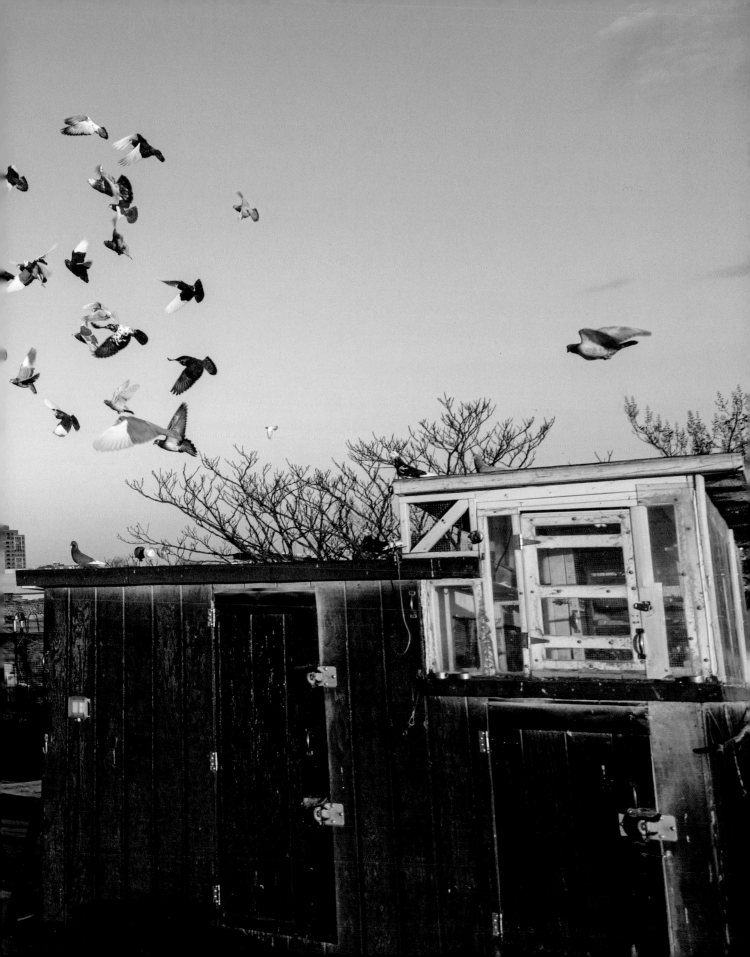

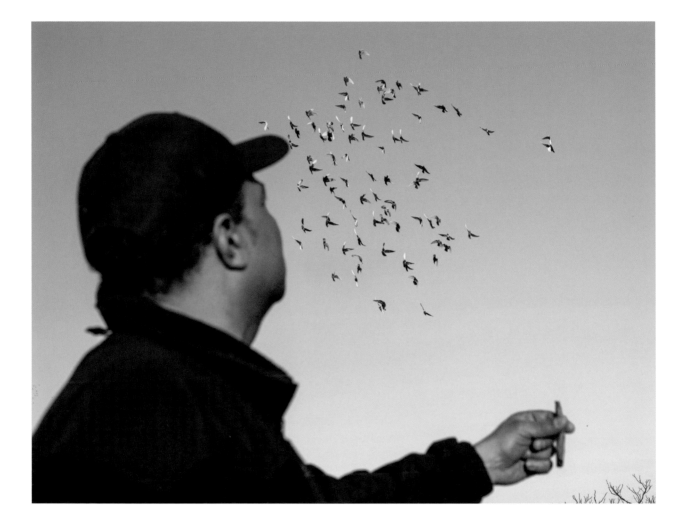

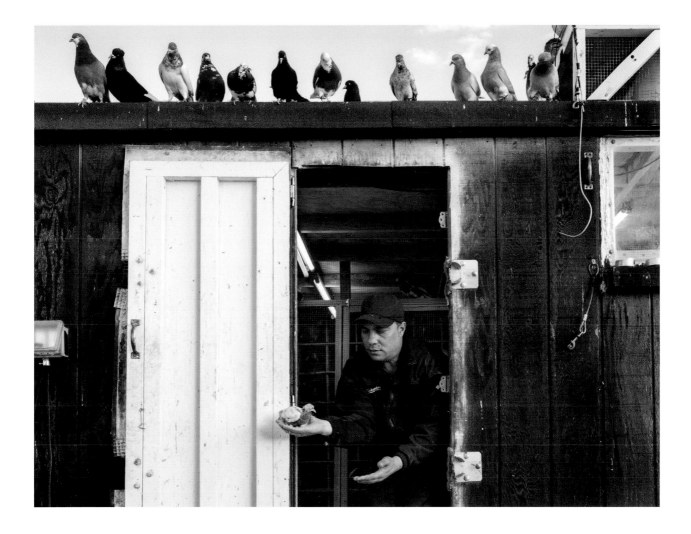

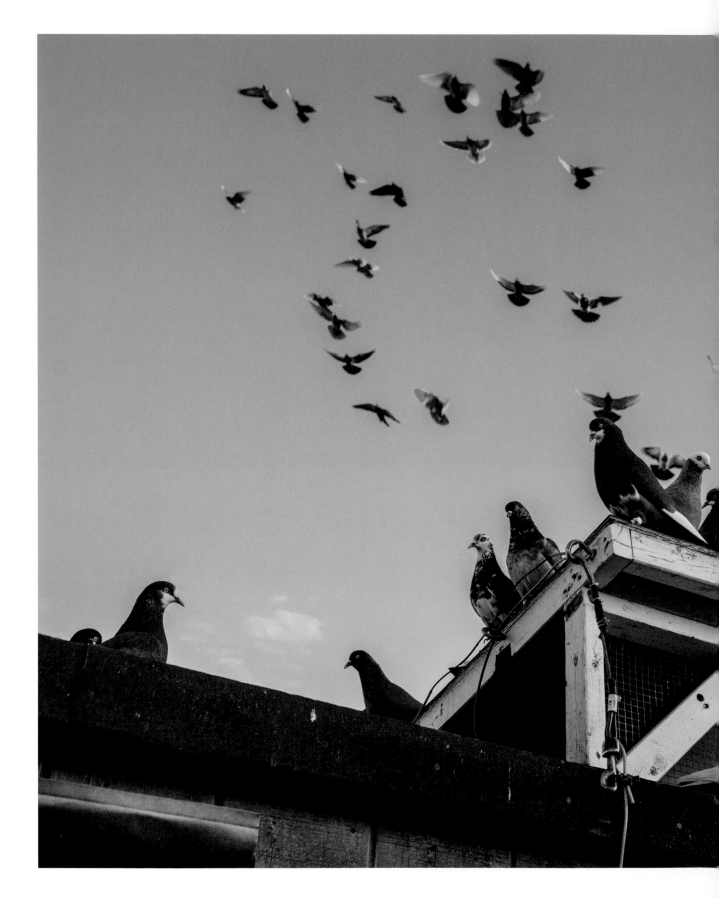

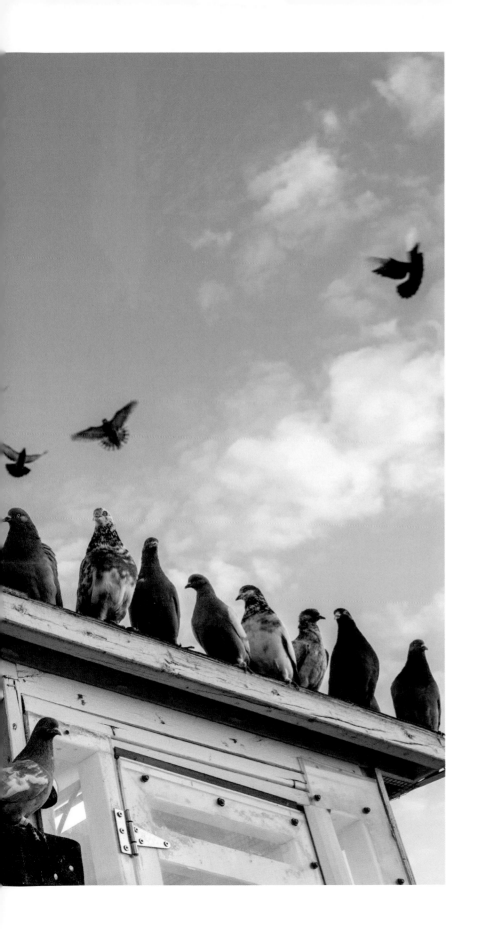

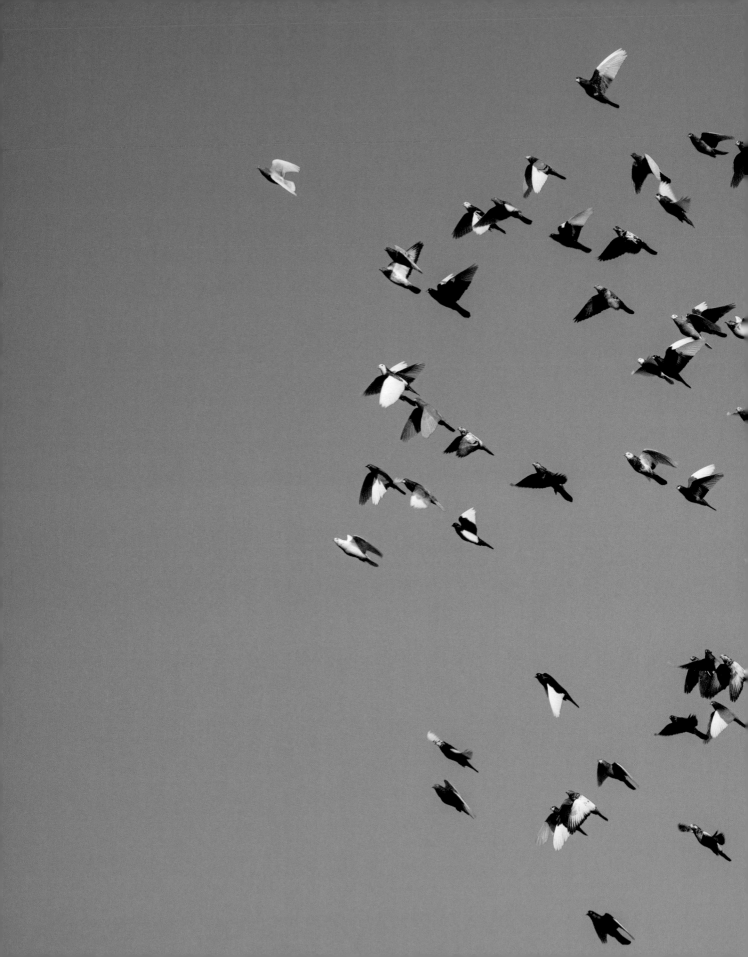

FIRE ESCAPES (MAY 15)

Fire escapes are the urban backyard and a defining architectural feature of New York City. If you're lucky enough to have one, it's probably your only private (but not secluded) outdoor space. While the dimensions are limited, New Yorkers make them work as dining rooms, reading nooks, and even art studios.

The average fire escape visit tends to be shorter than a rooftop visit, which makes sense considering the near-constant threat of danger on these high, narrow structures. Most people only come out for 10 - 15 minutes at a time, typically alone, for a beer, smoke, or breath of fresh air.

You can learn a lot about an apartment building from its fire escape. As the old buildings in my neighborhood are gutted and renovated to cater to a wealthier crowd, the fire escapes follow suit. While the traditional fire escape is a tight, functional space that can uncomfortably seat one or two people, gentrified buildings have expanded them into spacious terraces.

Fire escapes provide a visual metric for a neighborhood's spectrum of wealth. Lower-income residents, strapped for space in their apartments, often use fire escapes for added storage. Meanwhile, wealthier residents are likely to use fire escapes as extra room for leisure.

Regardless of style, the great unifier of fire escapes is the resident's awkward window entrance. This scramble is nearly impossible to do with grace and very fun to watch.

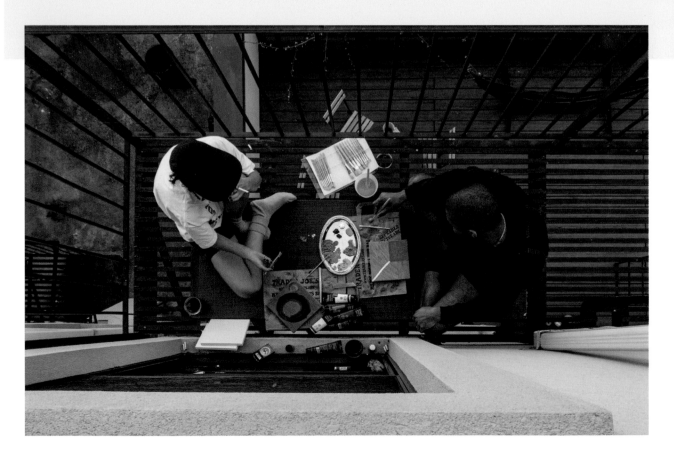

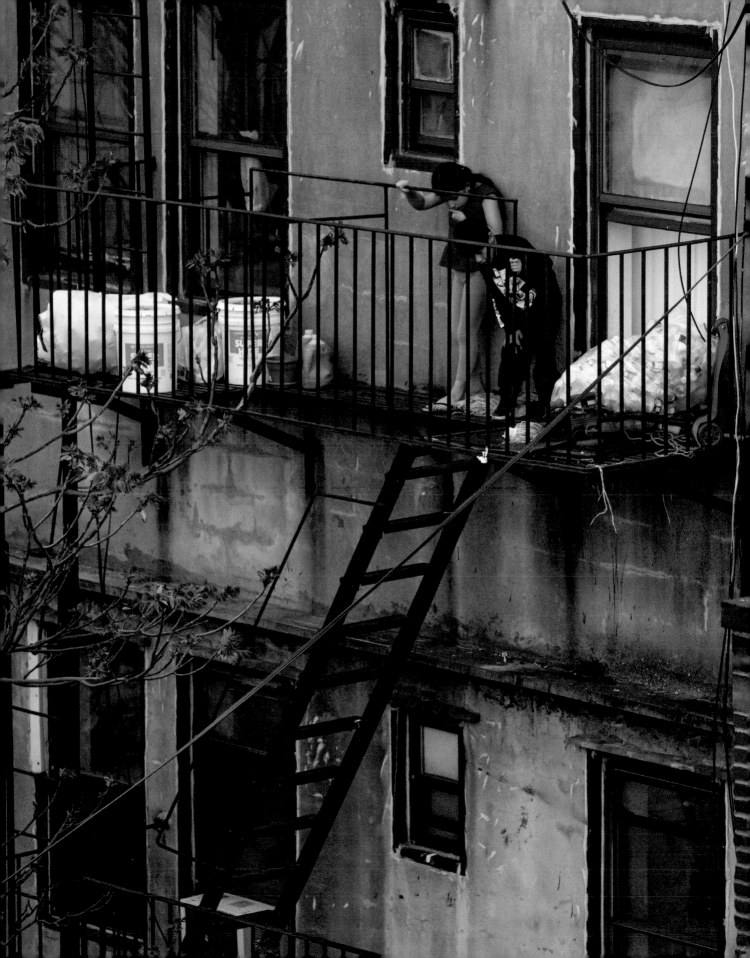

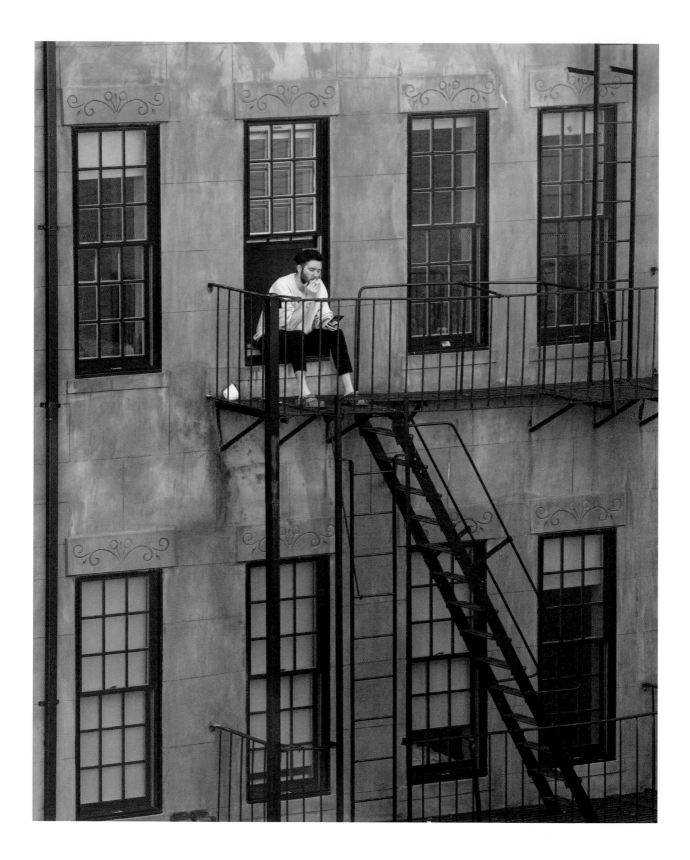

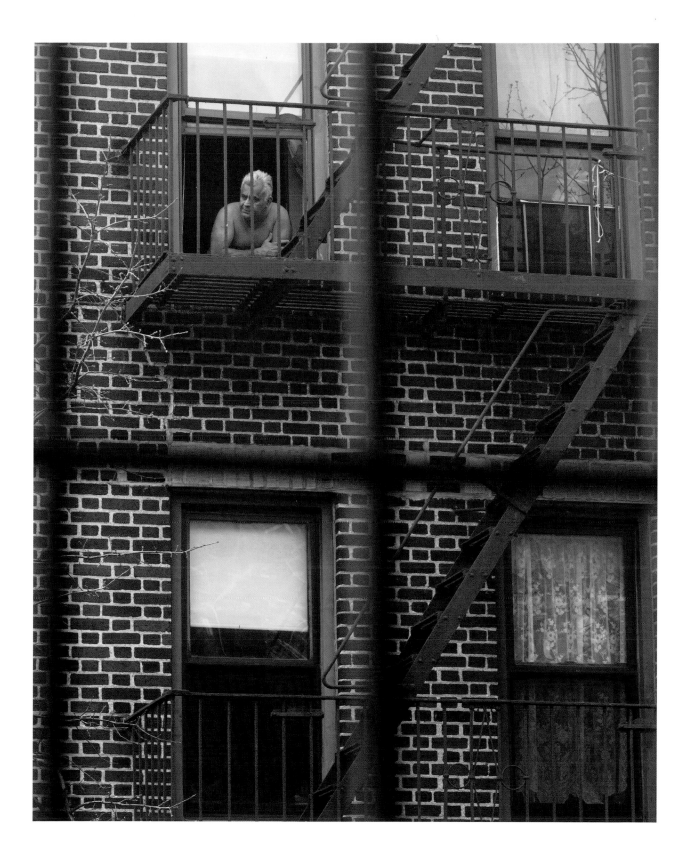

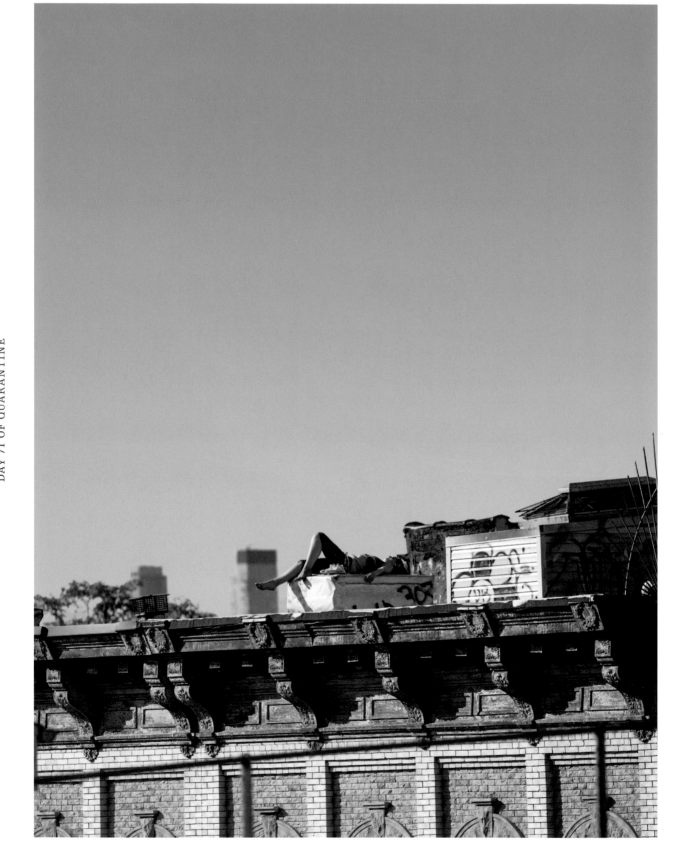

LOITERING* MANIFESTO (MAY 22)

"Loitering" is a word primarily associated with "no loitering" signs. However, it can be a beautiful thing, keeping the city safe, lively, and communal.

I've always envied city dwellers who spend all their free time hanging out in the same public space, whether it be in a park, at the corner, or on a stoop. Their attendance at this spot is like clockwork, providing the lifeblood of the city.

Jane Jacobs, the celebrated author of *The Death and Life of Great American Cities*, wrote that there should be "eyes on the street" to keep a neighborhood safe. The regular loiterers know the pulse of their street better than anyone, being the first to spot outsiders and potential danger.

Loitering creates the foundation for a tight-knit community in which gatherings are fluid rather than a coordinated effort. Loiterers tend to sit facing foot traffic, embracing the street theater and welcoming conversation with anyone who wants to chat, from old friends to new neighbors.

At its core, loitering is a rebellion against the organizational structure of the city. No agenda, no cost of entry, no exclusion, and no worries. It requires standing against the current of people rushing from point A to point B, relaxing outside of designated zones of leisure, spending time with whomever might be interested, and amassing community without rules.

Over the past two months on the roof, I've gotten a taste for this public relationship with a city. I haven't spent this much time outside since I was a kid. I don't make plans to spend time with my neighbors—we all know where to find each other and it's become a routine. I feel safe walking away from my camera bag since someone I trust is always nearby. For all of these reasons, my daily loitering habit has been essential to managing my mental health amid this pandemic.

While my rooftop is just a speck in the urban cosmos, I hope that other New Yorkers are having similar communal experiences on their rooftops or fire escapes, remembering that it all started with some healthy loitering.

While it's not technically loitering if you're on your own property, like your stoop or rooftop, I embrace the term because it needs to be destigmatized.

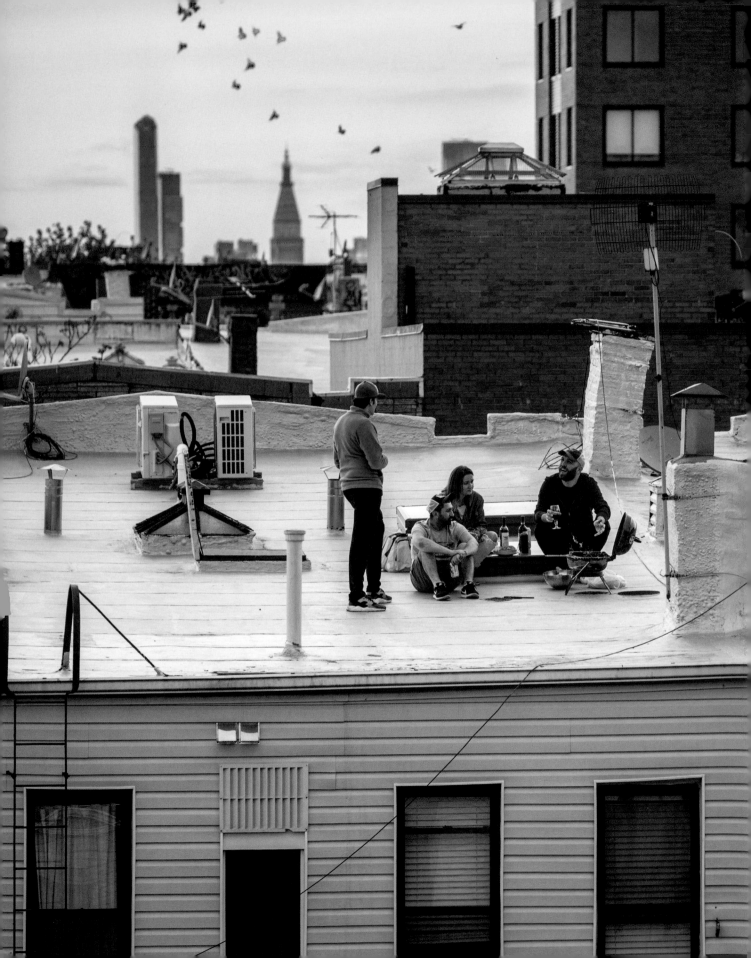

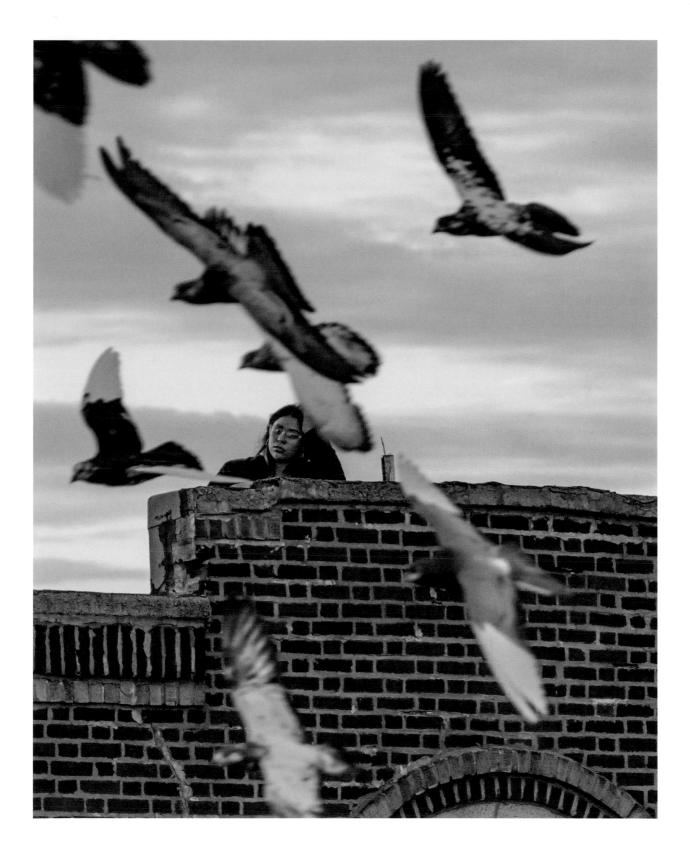

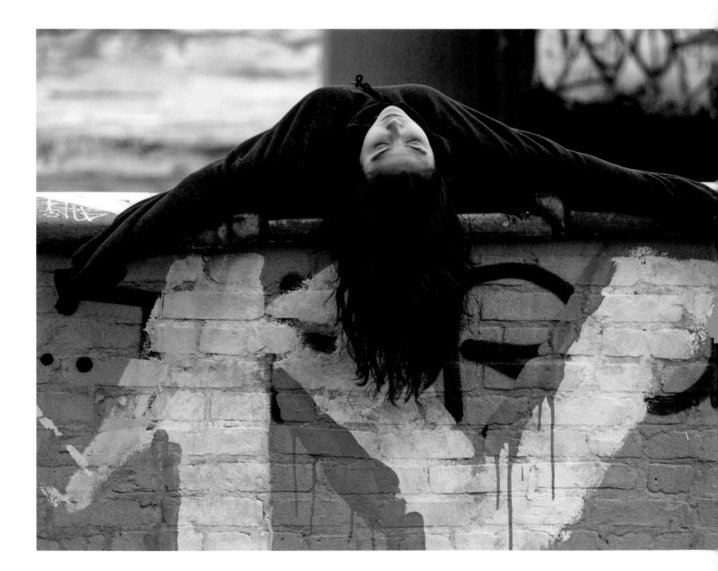

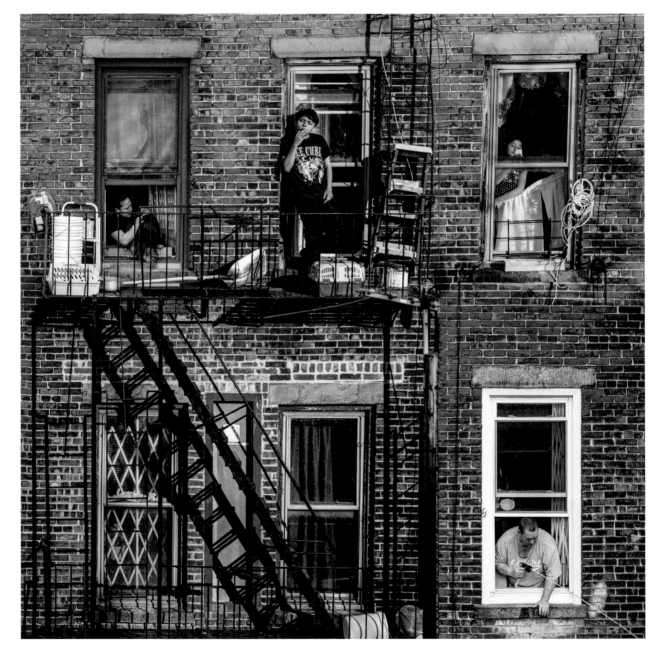

This is a composite of four photographs which
appear previously on pages 54, 55, 56, and 57.

LIVES OVERLAPPING (MAY 29)

New York City is a dense potion of people, bubbling into countless unexpected interactions, bursting into shouting matches and laughter between strangers. From the casual exchange of "fuck you"s in traffic to a stranger helpfully pulling you into a subway car that clearly has no space, these moments make New York special. Since the pandemic struck, personal space is respected for the first time in the city's modern history.

Observing the microcosm on the roof has helped me better understand how people live in New York City. They occupy the same spaces but in different moments of time, and tend to use the same communal spaces for the same activities. It's no coincidence that I've seen four couples enjoying dates on the same ledge. There's a sense of community to be found in the repeated use of these spaces, a lingering warmth left over from the previous occupants. Despite the many ways to sit on a rooftop, optimizing view, ease of access, feng shui, and safety (or lack thereof), our shared human instincts cause our lives to overlap in space, if not in time.

In buildings full of congruently designed apartments, our lives can seem like parallel realities. It took a composite to bring these realities into the same frame, but these harmonious moments are happening all day and night. Since the city's on a firm grid system, almost everyone sleeps parallel or perpendicular to one another in neat stacks. If only we could see through walls.

This is urban congruence, a foundation for the community of New York. Our individual behaviors, which may feel random and isolated, form a collective even when we're not aware of it. While community gatherings have waned, we'll always be unified by space.

THE WORLD KEPT CHANGING (JUNE 2)

On May 25, 2020, George Floyd was killed by Derek Chauvin, a white Minneapolis police officer who knelt on his neck for over nine minutes, ignoring Floyd's desperate pleas of "I can't breathe." This act of violence was a watershed moment that sparked a wave of global protests against police brutality. It was not, however, an isolated incident.

George Floyd was a new name on a long list: Ahmaud Arbery, Alton Sterling, Atatiana Jefferson, Aura Rosser, Botham Jean, Breonna Taylor, Daniel Prude, Eric Garner, Freddie Gray, Michael Brown, Rayshard Brooks, Stephon Clark, Tamir Rice, Tony McDade. This list is a fragment of the victims of hundreds of years of oppression and systemic racism in America.

Throughout the summer of 2020, protests erupted in Minneapolis and soon spread to Chicago, New York, and every major city in the country. They trickled down to the suburbs and traveled across the world. People joined marches, vigils, and unity bike rides. They hung posters, made murals, and spoke out on social media.

I disrupted my daily rooftop journey to join protest marches throughout the city for many consecutive days in the first two weeks of June. I marched alongside tens of thousands of others to show support for the movement, to be there for my city, and to understand what was happening when news coverage seemed to range from insufficient to misleading. I joined to stand against injustice, and because these protests made everything else in my life feel paltry, begging the question: "how could I *not* be protesting right now?"

The protests I encountered were largely peaceful aside from the occasional tense moment fueled by combative police. This got worse after dark, which continued to be the case for several long days. The pulse of the city changed after sunset; nightly lootings and riots began, stoked by violent agitators and opportunists. In response, Mayor Bill de Blasio imposed an 8pm nightly curfew.

These curfews, and the near-constant presence of helicopters overhead, made New York City feel like a police state at a time when police have never been less trusted. Just as quarantine was easing up and people were beginning to leave their apartments, parts of New York receded into a boarded-up ghost town. While this was heartbreaking for the city, I saw the quiet streets as the byproduct of our reckoning with the racist structures on which our society was built and their violent modern-day consequences.

Through the work of the Black Lives Matter movement, the city is gaining a greater awareness of anti-racist ideology, heightened scrutiny of the police, and newfound empowerment of youth activism. New York City and our country still have a long way to go, but it's hard not to feel a national awakening has begun.

POSTSCRIPT – APRIL 20, 2021
One year later, despite video evidence of the murder of George Floyd in its entirety, the world anxiously awaited the verdict of Derek Chauvin. To a global gasp of relief, Chauvin received a guilty sentence on all three charges, including second-degree manslaughter, setting a precedent for the police to actually be held accountable for their actions. While only time will tell if this is a real turning point or just an anomaly, we can celebrate today.

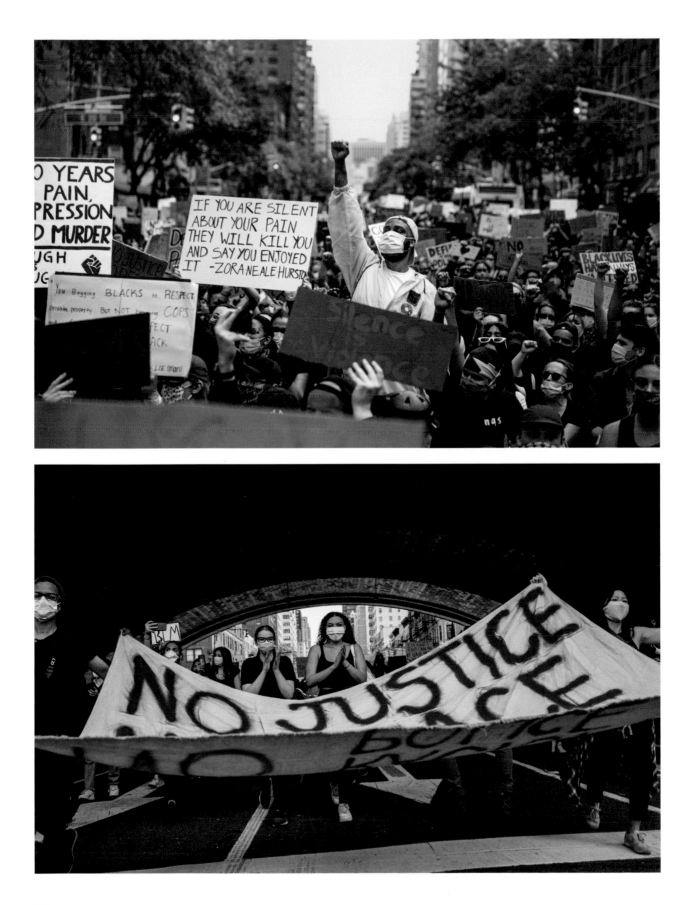

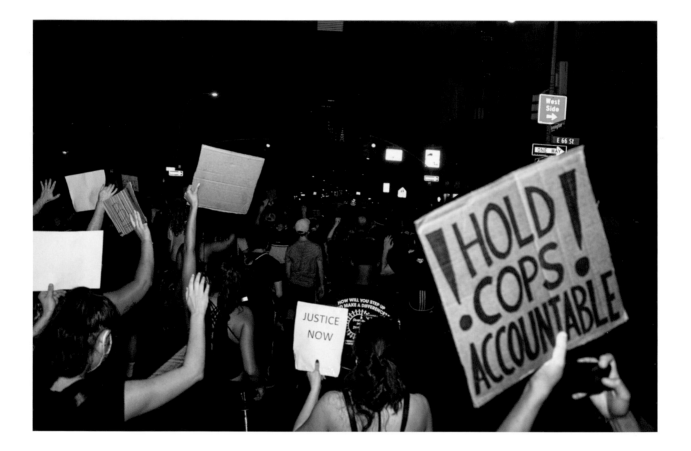

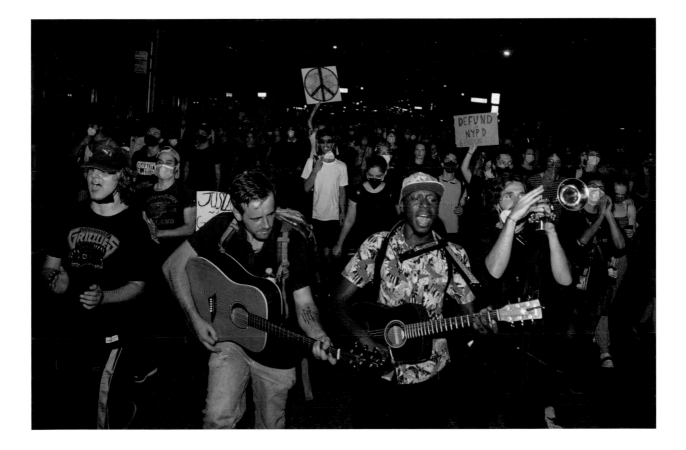

PURSUIT OF HEIGHT

Why do we love rooftops so much? Besides the obvious perks—
fresh air and expansive views—I suspect it's because climbing
fulfills our simple desire to rise to the top.

This is best illustrated by people's urge to climb to the highest point
possible, even at the cost of comfort or safety. Never content,
they clamber on top of chimney tops, AC units, and parapets in the
dangerous pursuit of marginally better views. It seems to
be a natural summit on the journey to any roof.

It may be for a simple thrill, a playful balancing act, or an extra
layer of privacy from neighbors below. Is it the same instinct that
compelled people to build new settlements atop hills? The same
urge that makes the childhood game, "King of the Hill," so intuitive?
Or has quarantine revived a long-dormant urge to explore?

It's hard to say for sure, but I certainly appreciate my neighbors'
love for this extra climb, which transforms the average rooftop
dweller into a pensive hero overseeing the city.

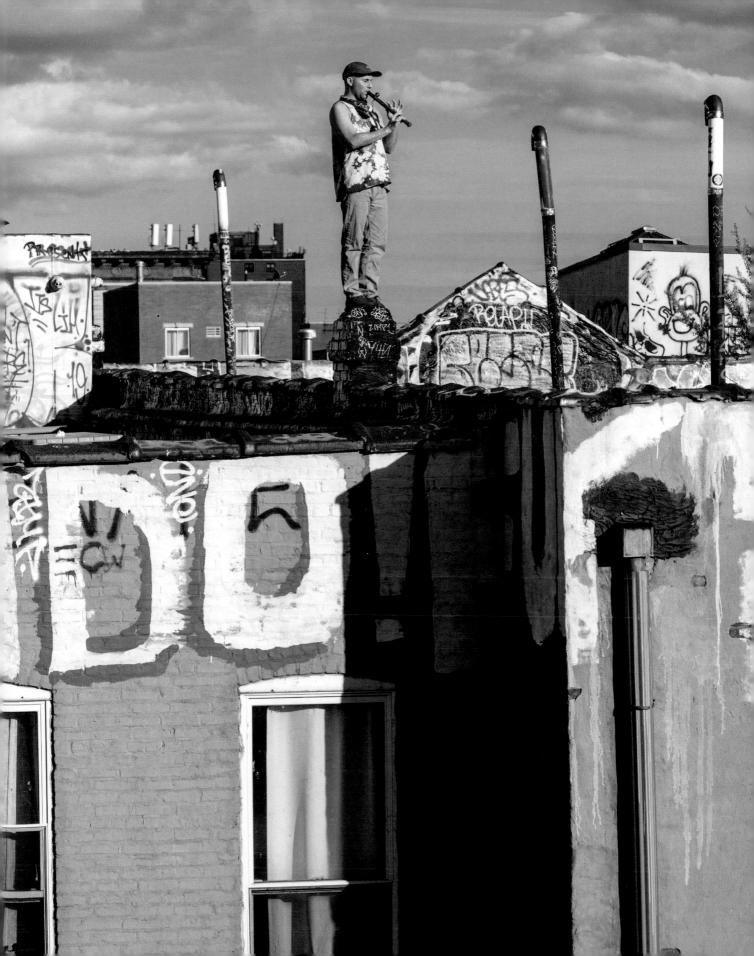

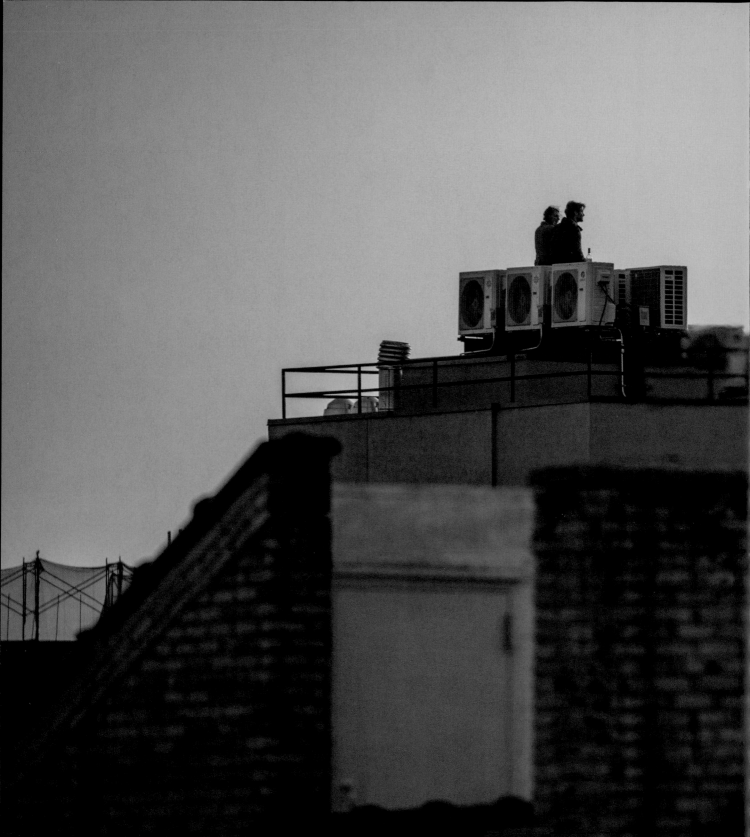

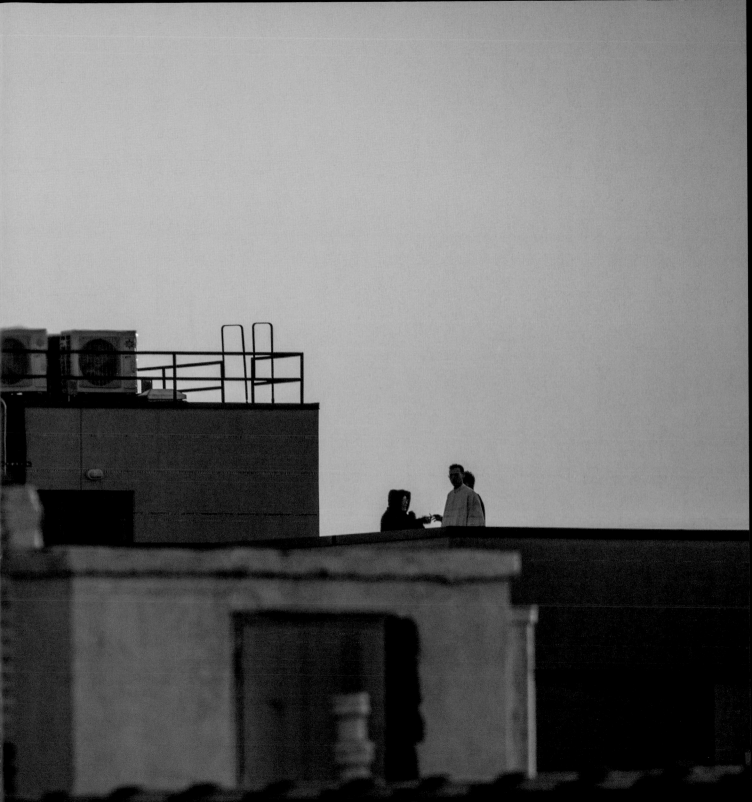

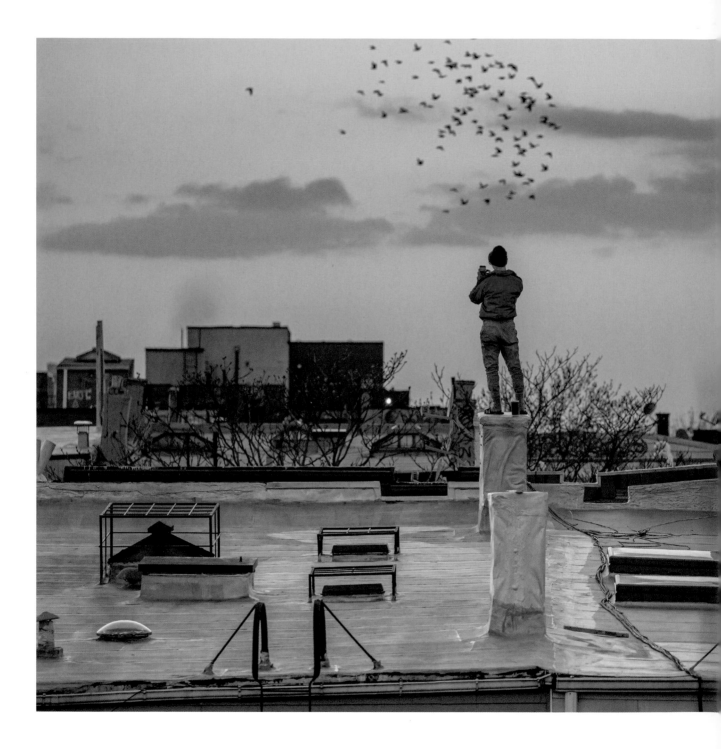

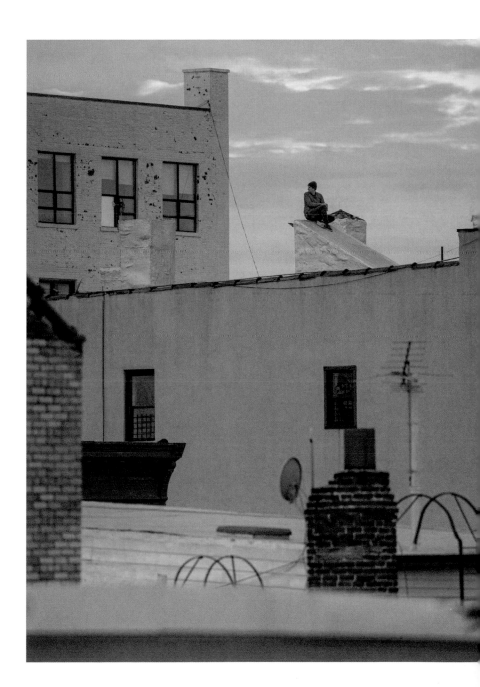

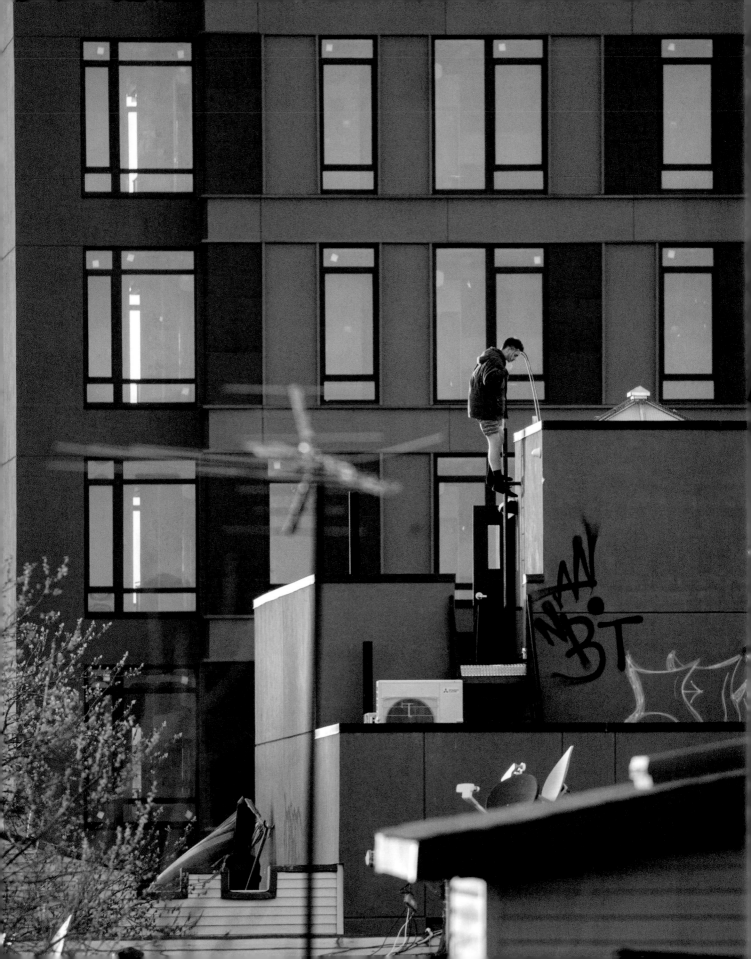

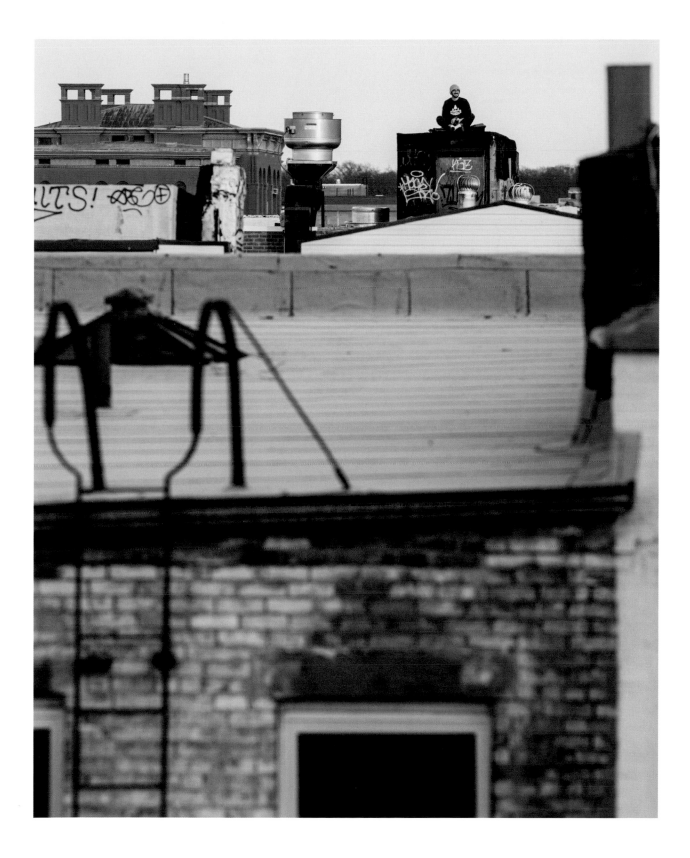

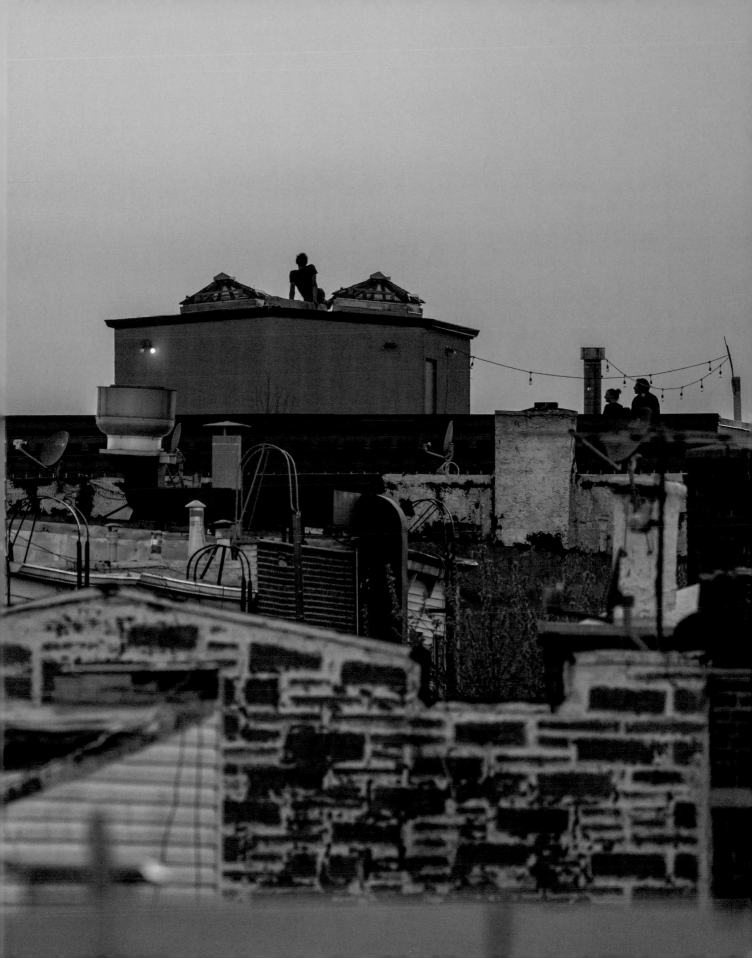

EPILOGUE (MARCH, 2021)

It was difficult deciding when to end this series. For over two months, I spent every evening on the roof sharing drinks, dances, and lofty conversations with neighbors, often late into the night. While spending time there began as a creative outlet, it gradually became my community.

For the first few weeks of quarantine, the energy across the rooftops was intoxicating as the days got warmer and more neighbors climbed up. Missing even a single evening on the roof brought overwhelming FOMO, knowing something spectacular was probably happening up there. The first time I missed an afternoon on the roof to reunite with pre-pandemic friends, I got home to discover I'd missed an incredible concert from an impromptu band of musicians who found each other because they happened to live in the same building.

By mid-May, the rooftops quieted down as people gradually began moving on with their lives. Small closed-circuit "social pods" were formed so people could see their friends again, streets were pedestrianized, and parks became the epicenter of our social lives. At the end of May, I took my first prolonged break from the roof to join the protests against police brutality following the murder of George Floyd, which jettisoned a large population out of strict quarantine.

By fall, the pandemic still seemed far from over. There was an impending second wave in New York City and no one knew what to expect. It seemed likely the rooftop renaissance would not be repeated. New Yorkers will always turn to their roofs when there is nowhere else to go, but this requires the social desperation and uncertainty of an unexpected quarantine.

New York City has been, objectively, one of the more difficult places to quarantine. Without a rooftop or fire escape, many people are cooped up in small apartments with too many roommates and no access to the outside world. Most people with places to go outside the city will choose to flee.

While many stayed out of necessity, I'm always curious to hear from those who stayed when they could have left. I stayed because I believe in this city. It's my home and New Yorkers pull together in the toughest times. In March of 2020, I wasn't sure how, but I knew I'd be documenting the city's fight against the virus.

In trauma, people come together and form lasting bonds. Three weeks in quarantine can feel like three years or three days, depending on your mindset. When my roommate fled the city in March, I was left to quarantine in the apartment by myself for five months. The rooftop is what kept me sane, giving me human connection, purpose, and hope.

At the time of this writing in March 2021, the city feels hopeful. Vaccines, which felt like a distant fantasy a year ago, are being widely distributed; the days are getting warmer again, allowing for comfortable outdoor socializing; and the city has settled into a functional "new normal." There are still uncertainties to be dealt with—new variants of the virus, vaccine distribution, and skepticism of vaccine efficacy—but I remain optimistic.

While the pandemic was a scarring experience for New York City, as it has been around the world, I hope this book serves as a reminder that there were beautiful moments in the darkest days.

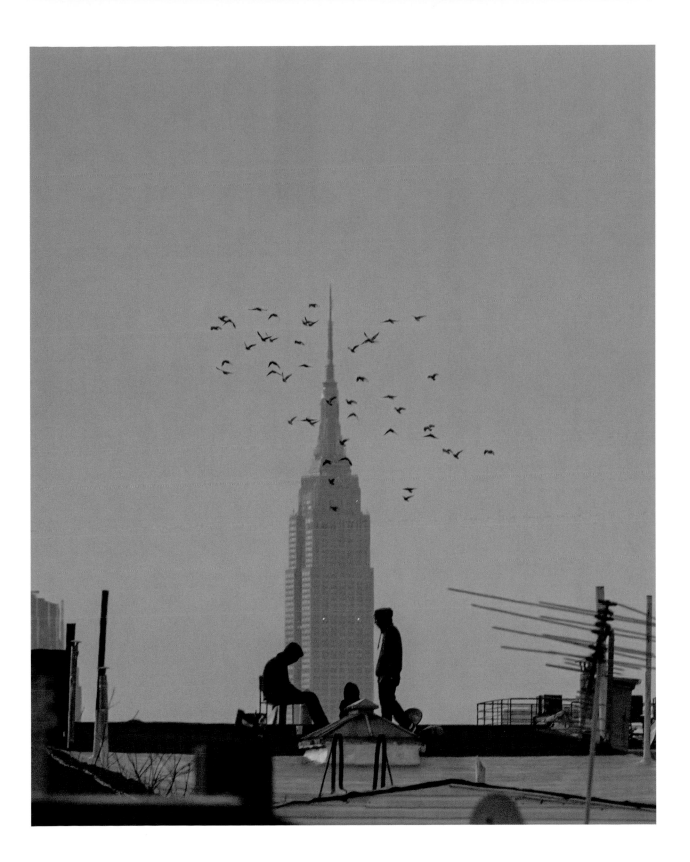

08

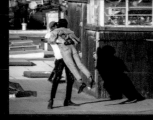

10

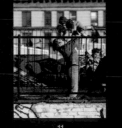

11

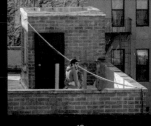

12

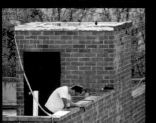

13

15

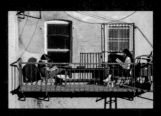

15

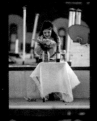

17

18

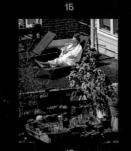

19

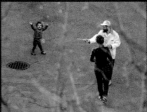

21

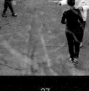

22 – 23

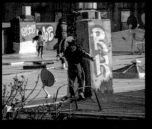

24

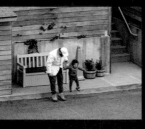

25

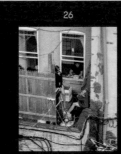

26

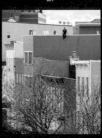

27

28

29

30

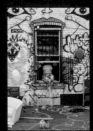

31

32

35

36

37

38 – 39 41 42 43

44 46 47 48

50 – 51 52 – 53 54 55

56 57 59 60

61 62 – 63 65 66

67 69 72 73

74

75

77

78

79

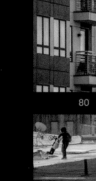

80

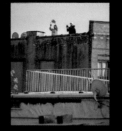

81

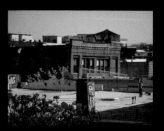

83

84

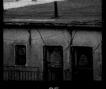

85

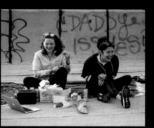

86

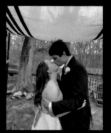

87

89

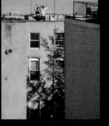

90

91

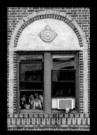

92

94 – 95

97

97

97

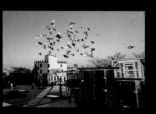

98 – 99

100

101

102 – 103

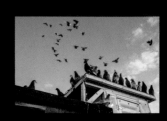

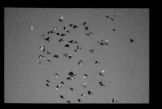 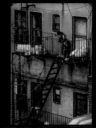

104 – 105 106 107 108

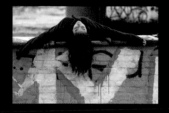 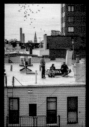

109 110 112 113

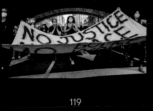 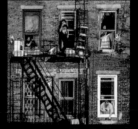 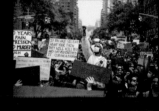

114 115 116 119

 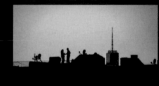

119 120 121 122 – 123

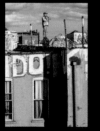 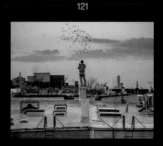

125 126 – 127 128 129

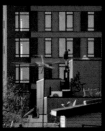 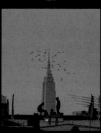

130 131 133 135

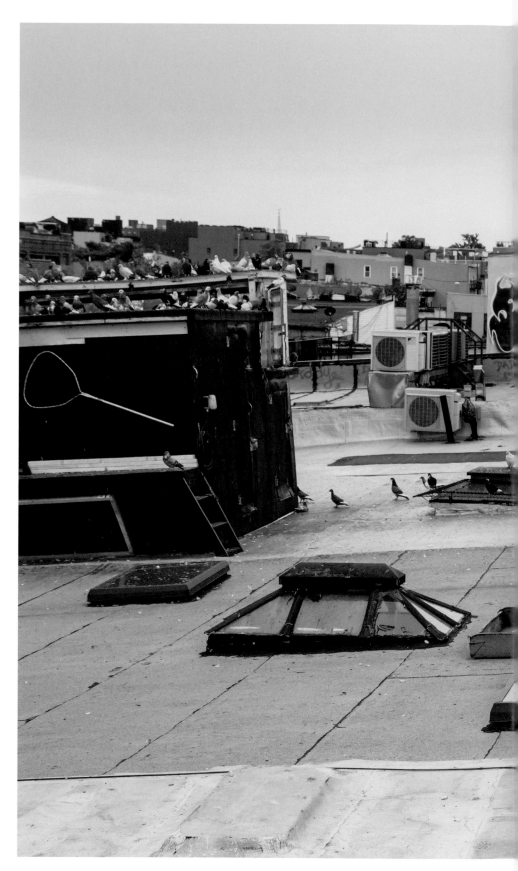

SELF-PORTRAIT OF THE ARTIST
*Shot with permission from the
neighbors whose apartment he
was skateboarding on top of.
Landlord permission pending...*

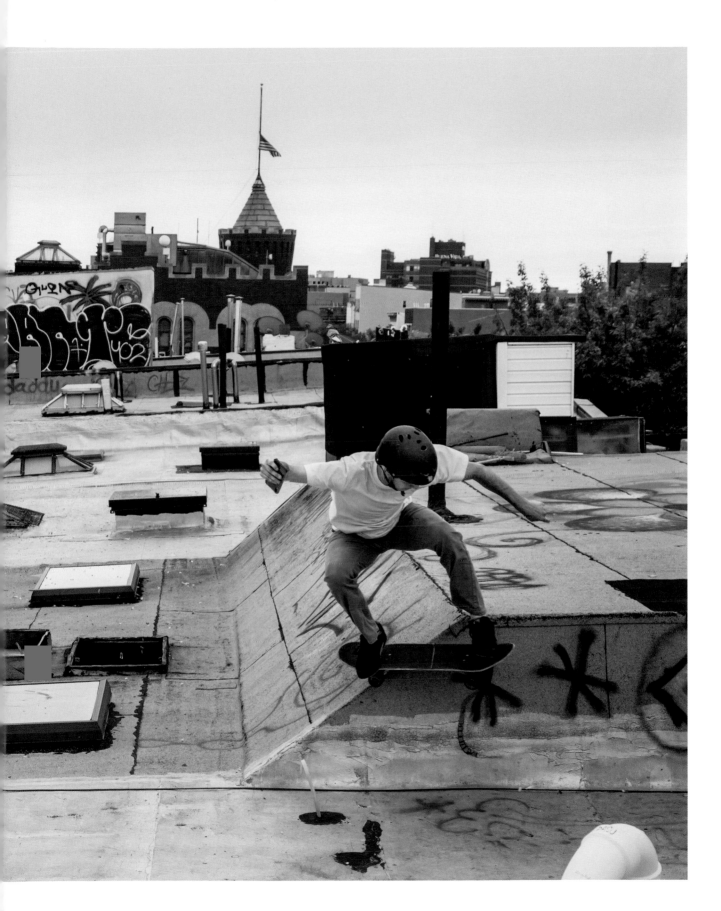

Acknowledgments

Photography & Writing: Josh Katz
Designer: Eddy Ymeri
Cover Designer: Lauren Peters-Collaer
Editors: Ellen Cranley, Elizabeth Keene, and Kyle Wright

First Edition

This book wouldn't have been possible without a fleet of incredibly talented people, three of whom were there from the very beginning. Eddy Ymeri did a stellar job designing this book from the ground up, patiently re-explaining grid systems every time my suggestions could potentially ruin them. Kyle Wright brought the writing to life as an intensive developmental editor, agonizing over every synonym and sentence structure with me. He did not force me to write this. Ellen Cranley caught all the grammatical errors that I couldn't claim were stylistic choices.

Lauren Peters-Collaer designed the magnificent cover. Rumaan Alam perfectly encapsulated the feeling of New York City quarantine in his foreword.

Thank you to my agent, Myrsini Stephanides, for believing in this project and responding to my cold email; Elizabeth Keene and the Thames & Hudson team for sharing my vision while reigning in my absurd ideas, elevating this book to previously unimaginable heights; Gil Arciliares and the pigeon fanciers for the friendship, support, and chop-busting that fueled this project; and the entire rooftop community for trusting me as a friend first and documentarian second. Without you this project would never have come to be.

Thank you to my siblings, Zach and Rachel, my parents, Josh Charow, Brian Garofalow, Gillian Doyle, Michael Mataluni, Greg Waters, Andy Schrock, Brian Ambs, the Revive family, Ricardo Camargo, Steve Llarosiliere, Jon Levy, NYC SPC, Adorama, and everyone who supported this project on Kickstarter.

First published in the United States of America in 2021 by
Thames & Hudson Inc., 500 Fifth Avenue, New York, New York 10110

Copyright © 2021 Josh Katz
Foreword © 2021 Rumaan Alam

Library of Congress Control Number: 2021935380
ISBN 978-0-500-02491-1

Printed and bound in China by RR Donnelley

Be the first to know about our new releases, exclusive content and author events by visiting
thamesandhudsonusa.com

Cover photographs by Josh Katz

Co-Contributors

We made a book! This was only possible with the faith and support of a large group of spectacularly generous people. This community came together on Kickstarter, where **700** people pre-ordered this book to fund its publishing. Below are the names of the exceptional contributors who went above and beyond in their support of this book. I am endlessly grateful to them and to everyone who supported this project in such tumultuous times.

Aditi Shankar	Eyers Family	Michelle Enkerlin
Alex Brookins	Fehmi Özkan	Miguel Angel Ortega Casas
Alix L. Hatzidakis	Gregg & Jill Konopaske	Mike Katz
All Day Dreaming	Gustavo Aurelio Monasterios	Moira Hally Cranley
Amy Koko	J Smid	Muyang Song
Anne Kornfeld	JC.Dwyer	NYCBUDDHA
Arda Dakilic	Jason B. Quizhpi	Nik Conklin
Barbara & Jeffry Waldman	Jeffrey Curry	Olivia & Alex Rusin
Barbara & Katie Van Bergen	Joanne Engfer	Patrick Assunção Goodwin
Björn Hansen	JuLee Kim	Paul & Amelia Remy
Brendan Beyer	Kate Babis	Paulo Dias
Brian Garofalow	Katharina Mueller	Ray Todd
Chad Reynolds	Katrin Eismann	Richard Vande Stouwe
Christian Ortiz	Kelly Becker	Silas Family
Christian Wetzel	Libby Luoma	Spanky
Christopher Singh	Lisa Croll & David Lieberman	Street Sweeper Magazine
Connor Mackay	Luiz Peixoto	Susan A. Bush & Rich Jackim
Cyrus Rosenberg	Madek Orth	T. Mitchell Gagorik
Daniel Neckonoff	Maggie Simms	Trevor James Fuller
Debbie & Jon Katz	Martin Hamburger	Valeria Orellana
Eileen Hoggarth	Martin Taylor	William Bohlen
Elizabeth Schultz	Melanija Tacconi	Winston Stalvey
Epner Family	Meseroll	Wouter Jansen

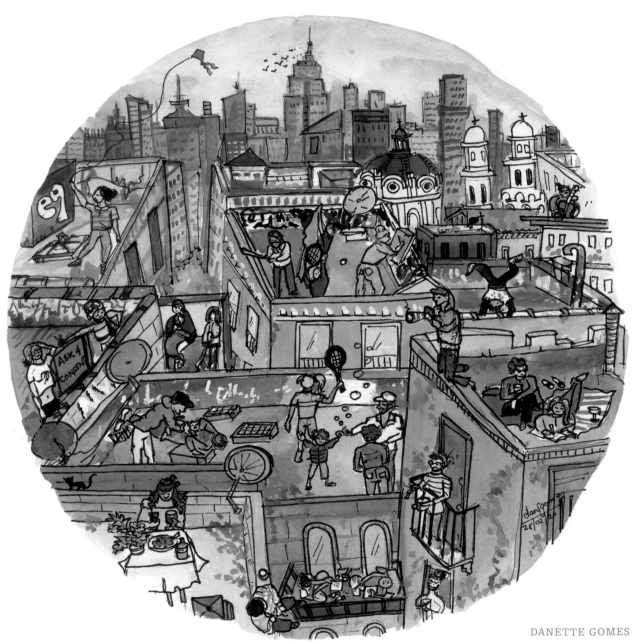

DANETTE GOMES
Illustration featuring neighbors
photographed in this project.